MW01037351

Baby Bird Portraits

by George Miksch Sutton

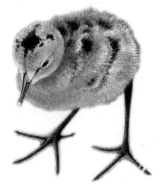

Baby Bird Portraits
by George Miksch Sutton

Watercolors in the Field Museum

By Paul A. Johnsgard

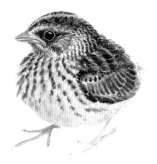

Foreword by Benjamin W. Williams

and William R. Johnson

University of Oklahoma Press : Norman

Also by Paul A. Johnsgard (selected titles)

Ducks, Geese and Swans of the World (Lincoln, 1978)
The Plovers, Sandpipers and Snipes of the World (Lincoln, 1981)
The Grouse of the World (Lincoln, 1983)
The Cranes of the World (Bloomington, 1983)
The Pheasants of the World (Oxford, 1986)
The Quails, Partridges and Francolins of the World (Oxford, 1988)
Bustards, Hemipodes and Sandgrouse: Birds of Dry Places (Oxford, 1991)
Cormorants, Darters and Pelicans of the World (Washington, D.C., 1993)
(with Montserrat Carbonell) *Ruddy Ducks and Other Stifftails: Their Behavior and Biology*
 (Norman, 1996)

Published with the assistance of the National Endowment for the Humanities, a federal agency which supports the study of such fields as history, philosophy, literature, and language.

The photographs of paintings by George Miksch Sutton included in this volume are © The Field Museum of Natural History, Chicago. Negative numbers are listed on page 81.

Sutton, George Miksch, 1898–
 Baby bird portraits / by George Miksch Sutton. Watercolors in the Field Museum / by Paul A. Johnsgard.
 p. cm.
 Includes bibliographical references and index.
 ISBN 0-8061-2985-9
 1. Sutton, George Miksch, 1898– —Catalogs. 2. Birds in art—Catalogs.
3. Watercolor painting—Illinois—Chicago—Catalogs. 4. Field Museum of Natural History—Catalogs. I. Johnsgard, Paul A. II. Field Museum of Natural History. III. Title.
ND1839.S96A4 1998
598.139'022'2—dc21 97-30311
 CIP

Text design by Alicia Hembekides, set in Garamond 3 with displays in Present Script.

The paper in this book meets the guidelines for permanence and durability of the Committee on Production Guidelines for Book Longevity of the Council on Library Resources, Inc. ∞

1 2 3 4 5 6 7 8 9 10

Contents

Foreword

Most of the baby bird portraits in this book are published here for the first time, and the volume as a whole presents a substantial portion of the studies of young birds painted by George Miksch Sutton during his career.

Publication of this book is the conclusion of a chapter in the story of two collections rather than one. Ownership by the Field Museum of Natural History of a significant collection of original work by Sutton's mentor and friend, Louis Agassiz Fuertes, provided the rationale and motivation to acquire the Sutton collection. Together the two collections provide a dramatic illustration of the Fuertes-Sutton tradition of ornithological observation and depiction that has inspired generations of naturalists and artists.

By the accounts of all who knew them, Sutton and Fuertes were also inspiring as individuals to their friends and colleagues, sharing a remarkable spirit of generosity that made a lasting impression in every personal and professional relationship. Something of this spirit has been reciprocated in the fostering care of individuals who preserved these collections and contributed to their eventual arrival at the Field Museum Library, where Sutton's baby birds now reside in the Mary W. Runnells Rare Book Room along with Fuertes's great and final works, the Abyssinian bird portraits of 1926–27.

Sutton himself entrusted his baby bird portraits to his friend of thirty years, William Johnson, of Norman, Oklahoma. In 1986, four years after Sutton's death in December 1982, Johnson sought to place these paintings in an institution that would preserve the collection intact and that shared his desire to see the paintings published. Our introduction to the baby birds at the Field Museum was provided by Joel Oppenheimer of Douglas Kenyon Gallery in Chicago (now Kenyon Oppenheimer, Inc.). Acting on Johnson's behalf, and recognizing the appropriateness of lodging Sutton's paintings with the Field Museum's Fuertes collection, Oppenheimer brought the baby birds to the library to determine the museum's interest in acquiring the works.

A number of donors have contributed to the museum's collection of original Fuertes paintings. In 1929 Albert A. Sprague donated two large studio pieces he acquired in a Chicago gallery, studies of a goshawk (dated 1914) and a great horned owl (1918). In 1991 T. Stanton and Jean Armour donated a study of raptors (signed

but undated) with six small vignettes of various birds with their prey. But the Field Museum's Fuertes collection is best known for the 113 field studies Fuertes executed during the Field Museum–*Chicago Daily News* Abyssinian Expedition of 1926–27.

In August 1927, three months after returning from the expedition, Fuertes was killed in a tragic accident. Two months later C. Suydam Cutting, a member of the expedition, purchased Fuertes's Abyssinian studies from the artist's widow and donated the collection to the museum. In *To a Young Bird Artist* (Norman, University of Oklahoma Press, 1979), Sutton includes the last letter he received from Fuertes, in which the artist says of this collection: "We had a marvellous trip in Abyssinia, & among other things I got far the best lot of field studies I ever did on one trip, a hundred color studies & a lot of drawings. Many of the birds most curious & bizarre." In 1930 the Field Museum published a selection of thirty-two of these studies as an *Album of Abyssinian birds and mammals*, now long out of print.

The Mary W. Runnells Rare Book Room, where this Fuertes collection resides, is the gift of John and Louise Runnells and stands as a memorial to John Runnells's mother, the donor in 1969 of the library's remarkable copy of John James Audubon's *The Birds of America*. Since the dedication of this splendid rare book facility in December 1981 (just one year before Sutton's death), its reading room has served as an informal Fuertes gallery, graced with the three earlier studio pieces described above and an ever changing selection from the Abyssinian studies.

Thus it was that when Oppenheimer brought the baby bird collection to the museum for our examination, we first viewed Sutton's studies while surrounded by Fuertes's Abyssinian bird portraits. The experience gave substantial reality to the idea of a Fuertes-Sutton Tradition and settled our resolve to join these two collections. Through Oppenheimer, Brooks and Hope McCormick, knowledgeable collectors and enthusiastic supporters of the Field Museum, became the donors of the Sutton baby bird collection.

Paul A. Johnsgard was instrumental in initiating the publication of this book. In the summer of 1995 he visited the library to consult various works in the Edward Ayer Ornithology Collection held in the Rare Book Room. In the course of a general tour of the collections, he viewed both the Fuertes Abyssinian studies and Sutton's baby birds. On learning of our desire to publish Sutton's work, Johnsgard offered his assistance in finding a publisher and his expertise in writing descriptive accounts for each of Sutton's illustrations. He suggested the project to Kimberly Wiar, senior editor at the University of Oklahoma Press, whose enthusiastic appreciation of Sutton's work has resulted in the present volume.

Some of the illustrations in this collection were reproduced in articles Sutton published on his studies of juvenal plumage. Five of the baby birds, plates 16, 18, 21, and 29, appeared in the Bulletin of the Cranbrook Institute of Science (no. 3, 1935) in Sutton's "The Juvenal Plumage and Postjuvenal Molt in Several Species of Michigan Sparrows." Plate 24 was published in the Occasional Papers of the Museum of Zoology,

University of Michigan (no. 445, 1941), in "The Juvenal Plumage and Postjuvenal Molt of the Vesper Sparrow."

It is a pleasure to share the collection as a whole through publication of this volume and to participate in the warm appreciation of Sutton's work and character that is so widespread among those who knew him. Some have speculated on the role Fuertes played in forming and guiding Sutton's character, and no one makes clearer than Sutton himself the importance of his relationship with a man he felt "was phenomenal—a human being with powers beyond comprehension" (Preface, *To a Young Bird Artist*). A similar statement about Sutton might well express the consensus of his friends and colleagues. But I will leave the last word on that subject to William Johnson.

<div align="right">

BENJAMIN W. WILLIAMS
Librarian, Special Collections
The Field Museum of Natural History
Chicago, Illinois

</div>

George Miksch Sutton came to the University of Oklahoma in the fall of 1952. He was a respected ornithologist and painter of birds. Our meeting is one of my more vivid youthful memories. I was aware of his importance and felt rather bold when, as a student, I introduced myself. He was a gentleman of the old school and appeared to be genuinely interested in who I was and what my plans for the future were. That was the beginning of a friendship that lasted thirty years.

Sutton is considered by many to have few peers in the art of painting birds, although he was certainly expert in many other areas. His field work in ornithology was without equal; his writings were lyrical and meticulously accurate, his bird skins so well done that they are recognizable as his alone; his knowledge of classical literature and music was enviable and his ability to teach unparalleled. He was a true Renaissance man.

Although all manner of excellent qualities are attributed to him, his genuine interest in everyone he met is most memorable. In June of 1983, after his death, about twenty of his friends went on a birding trip to the Black Mesa country in far northwest Oklahoma. We discussed our memories of George Sutton and found that it had been he who had pursued friendship with each of us. We had all been in awe of him, but because of his concern and warmth—his sensitivity as a friend—each relationship became strong. We all found that he had had such a profound effect on us that our lives were changed.

We welcome publication of Sutton's baby bird watercolors for the insight into his dedication as an ornithologist and the gift he possessed as an artist.

<div align="right">

WILLIAM R. JOHNSON
Norman, Oklahoma

</div>

Preface

When I traveled to Chicago during August of 1995 to see the Chicago Art Institute's monumental retrospective Monet exhibit, I set aside a day to visit the Field Museum, mainly to look at some bird specimens but also to see some of the magnificent hand-colored plates in the famous nineteenth-century monographs by John Gould. Benjamin Williams, the librarian in charge of the rare book collection at the museum, kindly also volunteered to show me some of the original bird paintings in the library's art collection. First, he let me examine some of the stunning field portraits of birds and mammals produced by Louis Agassiz Fuertes during the museum's famous Ethiopian (Abyssinian) collecting expedition of the 1920s, which represent the essence of the artistic level Fuertes was attaining just prior to his tragic death in 1927. Then, like a magician playfully pulling rabbits out of his hat, Mr. Williams smiled and handed me a small portfolio of paintings. In it were nearly three dozen life-sized watercolor portraits of birds by George Miksch Sutton (1898–1982). They included a variety of downy nonpasserine chicks and nestlings or just-fledged juveniles of sparrows and other small passerines, plus a few comparative head portraits showing adults of these same species, all obviously painted from life.

Most of these paintings had penciled-in species identifications and dates that extended over much of Sutton's long ornithological career—the indicated dates of execution ranged from 1930 to 1962. Five of the portraits had no accompanying information as to the species illustrated, nor did they provide any clues about location or date. Locations indicated for the others began with Ithaca, New York, the site of Sutton's graduate-school studies (1930–31) and of a later thirteen-year period spent as curator of birds at Cornell University, until the early part of World War II. Many of the paintings reflected the period he had spent in the Ann Arbor area, while employed as curator of birds at the University of Michigan (1947–52). He conducted extensive field studies on nesting sparrows in Michigan, including their postnatal plumage sequences and patterns of behavioral development. Others of the collection were painted in his beloved Oklahoma, his adopted home during the last three decades of his life. Finally, a charming painting of a sleepy white-rumped sandpiper chick represented one of the last of many trips he took to the Canadian arctic; his

work there began during his graduate-school field research on Southampton Island in 1931 and continued until as late as 1969.

The University of Oklahoma had constituted Dr. Sutton's last and longest academic and intellectual home, where he was successively appointed as curator of birds and professor of zoology, research professor of zoology, and when he officially retired in 1968, as George Lynn Cross Research Professor Emeritus. Not surprisingly, the University of Oklahoma Press has been the publisher of all of his later books. As soon as I returned home I contacted Kimberly Wiar, senior editor at the Press, and thus set in motion the steps that eventually resulted in publication of this book. In the species accounts I have tried to catch the flavor of Dr. Sutton's interests and writings, without resorting to long quotations. For species about which he wrote little, I have relied on my own encounters with and memories of these birds; in his less technical writing, Sutton often used the first person, describing his personal experiences with birds.

Of the thirty-five paintings in the complete Field Museum collection of Sutton's baby birds, all but one have been included in the thirty-two color pages of this book, with two paintings rendered as a single plate in two cases: the chipping sparrow and Henslow's sparrow. This procedure left in limbo only an unlabeled study of a curlew chick—almost certainly a long-billed curlew—which differs in style from all the others in having a painted-in background. Reproducing this painting on the back jacket meant that the whole collection could be presented.

By way of explanation of terms used to describe the feathering sequences of young birds, the *natal* plumage is the plumage present at the time a bird is hatched or appearing soon after hatching. It usually consists of extensive down in birds having well-developed and self-feeding (precocial) young, such as grouse, quails, and shorebirds, but only some wispy down in those nestlings that are poorly developed at hatching and remain dependent on their parents for food and brooding for weeks or even months (altricial young), such as all songbirds. The feathers of the natal plumage are soon pushed out of their follicles and are replaced by a *juvenal* plumage; this process is called the postnatal molt and the birds are then properly termed *juveniles*. In this plumage the bird acquires its first set of functional wing and tail feathers, enabling it to fly for the first time (fledge). The familiar term *chick* has no scientific usage but is a convenient catchall description often applied to unfledged birds in either natal or juvenal plumage.

Soon after gaining flight, young birds, now called fledglings, begin to shed some or all ("incomplete" or "complete" molts) of their juvenal plumage in a postjuvenal molt. Thereby they acquire a *first-winter* plumage that they will carry over much or all of their first fall and winter of life. This plumage of so-called *immatures* (another convenient catchall and nontechnical term) may be distinctly different in appearance from the adults' *definitive* plumage, as for example in young gulls; it may resemble the adult female's plumage regardless of the young bird's own sex, as in rose-breasted grosbeaks and indigo buntings; or it may closely resemble the breeding plumage of its own sex, as in bobwhite quails, northern cardinals, and most sparrows. In nearly all

of the species described in this book, sexual maturity occurs during the first year of life, but the white-rumped sandpiper breeds initially in its second year.

Having the opportunity to observe and handle these marvelous watercolors, as well as to help facilitate their publication, has been as much an undiluted pleasure and rare thrill for me as being able, for example, to look through Charles Darwin's own microscope at Down House in England, or being surrounded by uncountable herds of migrating wildebeest on Tanzania's Serengeti Plain. The paintings constantly reminded me of the kind and gentle artist I knew as "Doc" Sutton and provided me with an insight into the caring pride of the people who had been responsible for originally depositing these gemlike creations with the Field Museum and for ensuring their continued preservation.

Baby Bird Portraits

by George Miksch Sutton

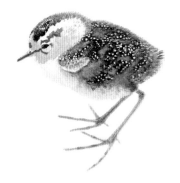

George Miksch Sutton's Art and Science

During the winter of 1980–81 I wrote to my longtime friend "Doc" Sutton, asking him if he happened to have a crane painting that might work as a dust-jacket design for my then forthcoming book on the cranes of the world. Failing that, I wondered whether I might be able to obtain permission to include a Sutton hummingbird painting for use in my book on North American hummingbirds, also then in production. He replied that he had no hummingbird paintings that would be suitable but added, "I do have a stunner of a flock of Sandhill Cranes with mirage-heightened Finlayson Islands in the background." In a later letter he said this scene was based on observations he and Dr. David Parmelee had made along the south coast of Victoria Island; he could not remember the exact day it was painted. I leaped at the chance to buy the original when he later offered to sell it to me, rather than simply to let me purchase one-time reproduction rights, as I had originally requested. The production editor of my crane book at the University of Indiana Press later decided that this marvelous painting was not "bright enough" to make an effective dust jacket and, in spite of my protests, a collage of cut-up plates from the book's color photo section instead appeared on the jacket.

Sutton's crane painting now hangs directly above my desk, having pride of place among a dozen original bird paintings on my office walls. In every way it is the simplest of them all. There are few colors present—white, representing the ice-covered coastline of Canada's Victoria Island; gray, a leaden and chilling sky; pale blue, the newly melted nearby ponds in coastal tundra; tawny brown, the still-dormant tundra and the upper parts of five flying sandhill cranes; sepia, the shaded underparts of the cranes; and finally a few hints of red, the unfeathered crowns of the cranes. Furthermore, shadows are nearly completely lacking, giving the scene a sense of total isolation and almost complete flatness. Although a horizon line is visible, the background is simplified to a minimum; only a fine line and some faint distant islands separate the glistening white ice of the frozen bay from the gray of the somber sky. All of these features remind one of classic Japanese woodblock prints. I have such prints from the early 1800s with a greater number of hues, and most of them with color tones that are at least as bright. The tundra-tinted cranes are flying low, in echelon formation almost at the observer's eye level, probably returning to their high arctic breeding grounds;

one bird has a widely opened bill and is obviously calling to the others. The painting is dated 1962 and is simply titled, "West of Cambridge Bay, Victoria Island, N.W.T."

This magical painting, one of many he made during two trips to the Canadian arctic during the 1960s, represents a kind of distillation of Sutton's life's work as a visual artist. An essay by the late artist and ornithologist Dr. Robert Mengel, written for a retrospective exhibit of Sutton's work during the 1984 annual meeting of the American Ornithologists' Union in Lawrence, Kansas, perfectly describes these paintings: "Without conspicuous prior attention to landscape for its own sake or to pure watercolor as such, Sutton surprisingly emerged as a landscapist of authority and a watercolorist of assurance, at one moment he lingered with delight over the intracacies of a lichen-covered rock, in the next he blocked out geometric reaches of receding ice, snow, water and tundra populated, of course, by birds lonely in the vastness. I have been there enough to feel the impact of the arctic that these pictures so well recall. Their sudden achievement would have been surprising in a painter of middle years. For a man near 70 it is impressive indeed." Roger Pasquier and John Farrand, Jr. (1991) describe this last major experimental series of painting as being "lightscapes" as well as landscapes, depicting the qualities of light reflecting off snow and illustrating the effects of light and shadow on tundra and its birds or mammals at least as much as delineating the characteristics of a particular species.

In an earlier memorial to Sutton (1983), Mengel wrote in glowing tribute, "If painters of birds were mountains and ranked according to height, it would be years before the completed survey of Mount Sutton permitted its placement. But the familiar shape of the mountain has quietly dominated the American landscape of living bird painters for years" (Arbib et al., 1983, 135–36). In the same memorial another accomplished bird artist, Al Gilbert, assessed Sutton's artistic and personal legacy: "As an artist, George Sutton will be ranked with Audubon and Fuertes as one of the great American painters of bird life; as a man, he will be held in even greater esteem by all who came within his orbit."

The wonderful sandhill crane painting that graces my office wall was completed nearly fifty years after Sutton's earliest published illustration; a sketch of a greater roadrunner in a frightened posture. That drawing appeared in the January–February 1915 issue of *Bird-Lore* (the predecessor of *Audubon* magazine) when Sutton was only seventeen, as part of a narrative account of general behavior and foraging activities of two pet roadrunners. The young Sutton was especially pleased to have his drawing included in that particular issue, since a color plate of juncos by the great bird artist Louis Agassiz Fuertes had been used as a colored frontispiece in the same issue.

Less than a month after his drawing and article were published, George Sutton summoned up his courage and mailed a personal letter to his idol Fuertes, apparently both praising Fuertes's artistic ability and asking for advice as to a possible eventual career as a bird painter. The letter he wrote no longer exists, but Fuertes's kind and generous reply was eventually published in Sutton's small and charming book *To a Young Bird Artist*, documenting their exchanges of correspondence and recalling

Sutton's fond memories of Fuertes. This letter, in which Fuertes volunteered to help Sutton develop his latent artistic talents, must have seemed like a miraculous gift to the youngster. It began a lively correspondence between the two and led to Sutton's spending the summer of 1916 with the Fuertes family along the shoreline of Lake Cayuga, near Ithaca, New York.

That summer obviously represented the most formative period in Sutton's artistic life, for during those few months he not only watched Fuertes at work but also received direct criticism and help from the master. The soft feather tones, a convincing treatment of shadows and highlights, and the elusive play of light on reflecting surfaces that Fuertes so readily captured in paint thus began to find their way into Sutton's own work. Two plates of greater roadrunners published seven years later in the March 1922 issue of the *Wilson Bulletin* show the influence of Fuertes on Sutton. Sutton's head portraits of a nestling and an adult roadrunner are of such quality that they might almost be confused with pages from a sketchbook belonging to Fuertes himself.

By the time Sutton became a graduate student at Cornell University in 1930, only three years after the tragic death of Fuertes in an auto-train accident, many paintings signed "George Miksch Sutton" had already appeared in national magazines and other publications. His first plate published in color, of a pair of pileated woodpeckers, was printed as a frontis for the March–April 1928 issue of *Bird-Lore*. This painting was the first in a series of six woodpecker plates published in *Bird-Lore* through 1930, Sutton's three alternating with plates by the well-known Canadian artist Allen Brooks. Sutton's woodpeckers were soon followed by color plates of such diverse birds as kingfishers, cuckoos, the coppery-tailed trogon, and a seemingly favorite subject of his, the greater roadrunner. In 1928 monochrome and color plates by Sutton also appeared in technical ornithological journals such as the *Wilson Bulletin*, and his first book was published, *An Introduction to the Birds of Pennsylvania*.

Several wonderful field studies of such diverse and colorful subjects as just-caught arctic char and live or freshly killed arctic sea ducks, painted during his 1929–30 fieldwork on Southampton Island, are reproduced in Sutton's autobiography *Bird Student* (1980) and clearly show his mastery of the watercolor medium. The earliest of the paintings reproduced in the present volume, a 1930 watercolor head study of an adult sharp-tailed sparrow (pl. 31), is noticeably lacking in feather detail and was obviously intended simply as a field sketch. By contrast, the adult Henslow's sparrow painted four years later has a more "finished" appearance and is startlingly Fuertes-like (pl. 30, right image). By the early 1940s, Sutton's paintings showed him to be the most accomplished bird artist of his time. By then he had also established himself as one of the finest and most prolific nature writers in the United States, besides being a field observer and ornithologist of the highest order.

George Sutton was especially attracted to depicting downy chicks, nestlings, and fledglings; portraying their soft plumages, large, bright eyes, and their innocent appearance provided a natural creative outlet for his own gentle nature. He also strongly

recommended the painting of baby birds to beginning bird artists, and described his views on painting such subjects in the March–April 1949 issue of *Audubon*: "Baby birds of all sorts make wonderful models. Some of them are excitable and restless and will no more 'stay put' than a healthy child would, but others will, when properly fed, stay in one position and allow an artist to study them carefully as he draws."

Sutton's interest in the developmental changes undergone by young birds, and especially in their postnatal plumage changes, led him during the mid-1930s to document the plumage development of several captive baby sparrows and their near relatives, such as buntings, grosbeaks, and cardinals, and to undertake many of the associated paintings that are reproduced in this book. An amusing account of these studies appeared in the September–October 1948 issue of *Audubon Magazine*, under the engaging title, "Tribulations of a Sparrow Rancher." Sutton was not reluctant to give his tiny subjects pet names, like Crousty and Second Place for two young northern cardinals he reared (pl. 8), and he tried to recognize and capture their individual personality traits and postures in his paintings. Thus, Nate Porter III, a friend who loaned Sutton a juvenile yellow-billed cuckoo as an artistic subject, exclaimed of the finished portrait (pl. 6): "It's mine, see! The very one I raised. You couldn't fool me. It's *my* cuckoo!" (Sutton, 1949). It is hard to imagine a greater tribute to any artist than to be able to evoke such an emotional response with a painting of a pet animal.

Sadly, George Sutton is now gone, his ashes scattered over the hills of his beloved Black Mesa country by loving students, but his artwork and writings remain with us as a unique contribution to American art and ornithology. Through these, many people can cherish him and his artistic and scientific legacies long into the future, even after all of us who were lucky enough to know him personally have also vanished from the scene.

Although I was never a student of Sutton's and was only a colleague in the broad sense that our years as academic ornithologists overlapped, so that I knew him mostly through correspondence while I was working on *Birds of the Great Plains*, I always felt a special affinity with him because of his Nebraska connections. He was born in Bethany, Nebraska, in 1898, where for a few years his father was a professor of elocution at Cotner College. Bethany then was a small village some distance northeast of Lincoln's outer limits. The Sutton family left Nebraska while George was still a youngster, never to return. Now Bethany is a Lincoln suburb and Cotner College has vanished, although Cotner Boulevard transects the very part of town where I have lived for more than three decades. I have sometimes wondered if the remnant grassland fragments that still supported such prairie birds as meadowlarks and dickcissels when I first moved to the Bethany area in 1963 were places where George Sutton wandered as a child, places that helped turn a young lad into such a keen observer of birds.

Similarly, when I arrived at Cornell in the mid-1950s, George Sutton had been there two decades earlier. His creative ghost still haunted the place, as did the earlier spirit of Fuertes, especially in the artwork of more recent ornithologists like William

Dilger. Sutton anecdotes still occasionally echoed through the top floor of Fernow Hall, where the ornithology graduate students had their desks (I wondered which had been Sutton's), and periodically I would scan the bird skin collection to touch and admire those beautifully prepared skins that bore the label indicating that Sutton had prepared them.

These are the sources of my claiming a special sense of connection to George Sutton and my attempting to interpret his work; I hope they are enough.

Plates and Species Accounts

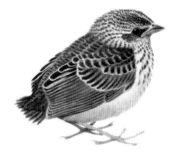

Plate 1

Northern Bobwhite (Colinus virginianus)

Like all the native North American quails, and in contrast to our grouse and introduced pheasants, northern bobwhites are monogamous and strongly social. Thus, the sight of a family of quails, being led by a closely attentive male and followed by his mate and a brood of as many as a dozen chicks, provides a powerful and unforgettable image of familial beauty. Their average clutch size is about twelve to fourteen eggs, which is an astonishing number for such a small bird to produce, especially since the entire clutch is often completed within two weeks.

Only the female incubates, and during that period the familiar bob-white call of the male is much reduced in frequency and volume. My own and other studies of this and several other species of New World quails indicate that individual recognition of a mate or covey member through vocal behavior is commonplace in this group. Nesting losses to predators and other mortality factors are quite high during incubation, and at times two or rarely even three nesting attempts may have to be made before the brood hatches, some twenty-three days after incubation has begun. Likewise, rather high mortality is common during the first week of life after hatching, and thus broods are typically reduced to about eight or nine survivors by early fall. Such family groups are the major basis for fall coveys.

It is interesting that groups of this approximate size also happen to be the ideal number for the formation of nocturnal "roosting discs." In bobwhites and a few other New World quails the covey forms a tight, outwardly radiating circle of bodies as the birds roost, their tails all pointed inward toward the center of the disc, their bodies in direct lateral contact, and their heads all directed outward. By adopting such a tight circular orientation the birds can conserve body heat during cold nights, can panoramically observe the entire landscape around them, and can simultaneously explode into flight, scattering in all directions, should danger threaten.

Despite such survival adaptations the mortality rate of northern bobwhites is extremely high, with about seventy percent of the entire population dying each year. As a result, the typical expected lifespan of these birds averages somewhat less than a year, even for those fortunate individuals surviving long enough to fledge successfully. Similar mortality rates occur in related species such as the scaled quail, a more arid-adapted species that sometimes hybridizes with the northern bobwhite where their ranges overlap.

Suggested Reading: Sutton, 1963 (hybridization with scaled quail); Johnsgard, 1973, 1988 (general biology); Stokes, 1967 (vocalizations).

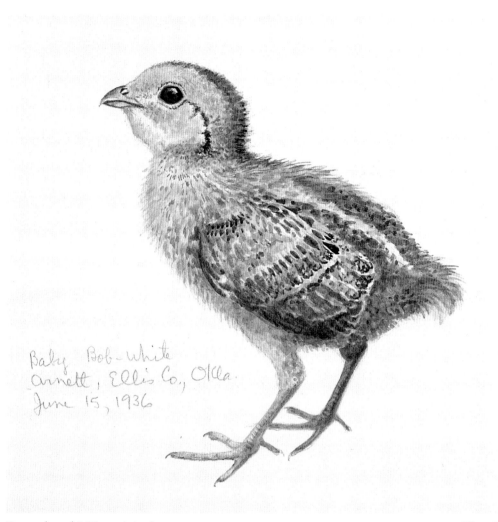

Baby Bob-white
Arnett, Ellis Co., Okla.
June 15, 1936

Reproduced 1.31 x original

Plate 1

Plate 2

Ruffed Grouse
(Bonasa umbellus)

The first time I ever saw baby ruffed grouse at the age shown in Sutton's painting was in June of 1953, shortly after I had arrived at Washington State University to begin graduate work. While wandering through a ponderosa pine forest and trying to learn some of the many unfamiliar species of plants, I was suddenly confronted with a rustling in the undergrowth, followed by the sudden appearance of an irate female ruffed grouse only about five feet in front of me. I reflexively raised my camera and quickly took several exposures as she stood there cackling loudly at me—she appears in my *Grouse and Quails of North America*.

I stood there as quietly as excitement permitted, balancing unsteadily, feet frozen firmly in place so as not to crush any chicks that might be in my path. Then I crouched down and gingerly began to seperate the vegetation before me. Soon I began to find the newly hatched chicks, each also crouching motionless and looking back fearfully at me as I carefully drew apart their screen of leaves. From above, they almost perfectly matched in background color the browns, blacks, and grays of the forest floor, and I might well have stepped on several had it not been for the mother's audacious defensive behavior. I backed up slowly and cautiously, making my retreat with as much haste as seemed appropriate. I observed about a half-dozen

chicks that day but probably did not find the entire brood, which presumably had begun as a typical clutch of seven or eight eggs. By the time the chicks have fledged at about ten days after hatching, the average ruffed grouse brood is likely to consist of less than half that number.

Most of my other memorable experiences with ruffed grouse have been with displaying males, mainly in Grand Teton National Park. Early almost every morning in May and June one can hear the distinctive accelerating drum-roll sound made by the male's wings as he beats them furiously, usually while standing crosswise on a dead log. By slowly turning one's head and cupping one's ears to obtain an optimum directional "reading," it is usually possible to detect the displaying bird's general location. Then, by approaching the drumming as quietly as possible (by walking only during the bird's actual drumming sequences, which evidently compromise its hearing), it is usually possible to stalk to within twenty feet or less of a displaying bird. Often one may thus briefly watch this amazing behavior before the male reluctantly retreats into the forest undergrowth.

Suggested Reading: Gullion, 1984 (general biology); Johnsgard, 1973, 1983 (general biology).

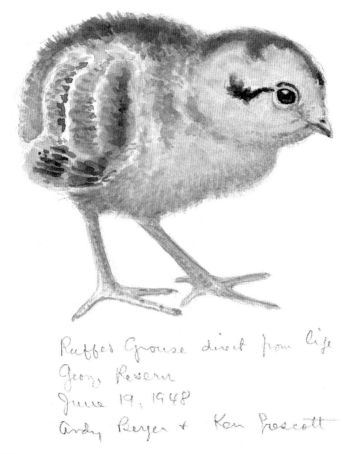

Ruffed Grouse direct from life
Geog. Revern
June 19, 1948
Andy Berger + Ken Prescott

Reproduced 1.53 x original

Plate 2

Plate 3

Lesser Prairie-Chicken (Tympanuchus pallidicinctus)

Lesser prairie-chickens of the southern Great Plains, together with the somewhat more widespread greater prairie-chickens of the native tallgrass prairies of the continental interior, the drastically endangered Attwater's prairie-chickens confined to the Gulf Coast prairies of Texas, and the extinct heath hen of the Atlantic Coast comprise the pinnated grouse group. Besides being breathtakingly and softly beautiful in their restrained dead-grass plumage tones, these endemic North American grouse exemplify the population trends of many native grassland bird species. Fertile grasslands are the first of the habitat types to be exploited and often destroyed by human settlers, which assures the destruction of the prairie-adapted species. The last male heath hen probably died in 1932, less than a year after I was born; people reading this book may live long enough to learn of the death of the last Attwater's prairie-chicken if present population trends continue.

Sutton's painting of the lesser prairie-chicken's natal plumage shows it to be similar to that of the greater prairie-chicken and the other pinnated grouse mentioned. Although the lesser prairie-chicken is currently regarded as a separate species, I have long believed that the smaller body size and somewhat paler plumages of this grouse population are not an adequate basis for regarding it as a distinct species but simply reflect its racial conformation to an arid grassland environment. Adult males of all of the pinnated grouse gather in breeding grounds called leks, the traditional display sites where the most aggressive males establish themselves as dominant. Only a few males survive the three to four years needed to attain this social status. Thereby they become attractive mating partners for the many females visiting the display ground each spring to be fertilized. It is a long, complex, and fascinating process, usually extending over several months each spring. Indeed, males become so attached to a particular lek after they have successfully established a territory there that they are unlikely to stray more than a mile or so from it for the rest of their lives. As noted in *Grouse and Quails of North America*, even after his compatriots had disappeared, the last surviving heath hen male faithfully returned to his traditional mating ground on Martha's Vineyard, Massachusetts, where he displayed alone to an unseeing and unhearing world.

Suggested Reading: Sutton, 1968 (natal plumage); Johnsgard, 1973, 1983 (general biology).

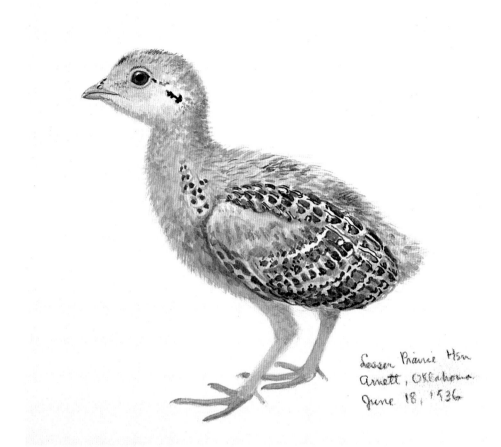

Lesser Prairie Hen
Arnett, Oklahoma
June 18, 1936

Reproduced .95 x original

Plate 3

Plate 4

Common Moorhen
(Gallinula chloropus)

The common moorhen is one of those species that many American bird-watchers and even professional ornithologists may detect occasionally over a lifetime but never actually see in nature; strange calls coming from heavy cover in a marsh may be the closest connection we ever are able to make with these extremely shy birds. Yet, in places like the royal parks of London, or in the display ponds of the Wildfowl and Wetlands Trust in western England, moorhens are so common and so tame that they are sometimes nearly trodden underfoot! This remarkable difference in behavior among populations of the same species must reflect rapid behavioral adaptations to the protection and unlimited feeding opportunities provided in these sites, pointing the way toward an understanding of the general process of domestication of wild animals.

Like their relative the American coot, common moorhens are highly territorial; indeed some of the earliest studies of avian territoriality were performed in England on these markedly aggressive birds. As for coots and other marshland birds, bright colors are not effective for communication in grassy and reed-covered wetlands; instead loud and complex vocalizations are employed for long-distance communication and advertisement. However, colors are useful for close-up interactions, and the bright facial colors present in the

chicks of moorhens and coots are certainly important social signals that may facilitate familial interactions such as parent-offspring feeding and brooding.

Suggested Reading: Fredrickson, 1971 (breeding biology); Sanderson, 1977 (general biology); Wood, 1974 (breeding biology).

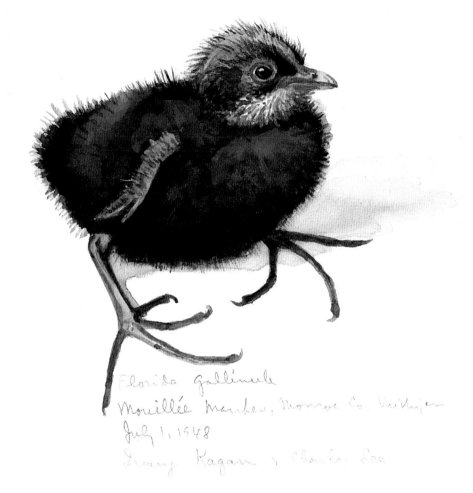

Florida Gallinule
Mouillée Marshes, Monroe Co., Michigan
July 1, 1948
Irving Kagan & Charles Seo

Reproduced 1.4 x original Plate 4

Plate 5

White-rumped Sandpiper (Calidris fuscicollis)

Even if one becomes intimately and confidently familiar with a particular arctic-breeding shorebird species by studying it farther south during spring and fall migration, this same species often seems a completely new kind of bird, miraculously able to transform itself, upon reaching its tundra breeding grounds. Then ordinary shorebirds may suddenly become quite extraordinary, perching on boulders or in low trees, singing elaborate and wonderful flight songs, or even in a few cases inflating their bodies with air, so that they may briefly come to resemble miniature balloons while inflight. Such is the case with the white-rumped sandpiper.

Spring and fall migrants that pass through the Great Plains in considerable numbers are not particularly memorable; my ornithology students simply grit their teeth upon seeing a flock of white-rumps, knowing that they may be required to try to distinguish these from all of the other half-dozen or so "peep" sandpipers that are equally likely to be present and are so confusingly similar in appearance. However, a sudden exposure of the white rumps of the birds as they take flight usually offers the students a brief but decisive opportunity for last-minute salvation from missing yet another species on their daily field quizzes.

On arrival at their high-arctic breeding grounds, male white-rumped sandpipers assume a totally new persona. Probably because the males are prone to taking multiple mates, they then become extremely conspicuous. Like pectoral sandpipers, male white-rumps often engage in prolonged display flights, with their anterior chest area somehow inflated and evidently serving as a resonating chamber for their territorial singing.

The downy white-rump chick Sutton painted was a newly hatched individual; the painting suggests that it was still unwary and perhaps had not recovered from the exertions of breaking out of its shell. Because Sutton did not paint the bird against its usual tundra background, it is impossible to appreciate how amazingly concealingly patterned the downy *Calidris* chicks are in life. I have sat for hours in a blind within a few feet of a newly hatched brood of similarly cryptic stilt sandpipers, and each time I let my eyes stray even briefly from the four downy, huddling mites, I found it almost impossible to locate them again among the patchwork array of lichens, herbs, and grasses.

Suggested Reading: Johnsgard, 1981 (general biology); Parmelee, Greiner and Graul, 1968 (breeding biology).

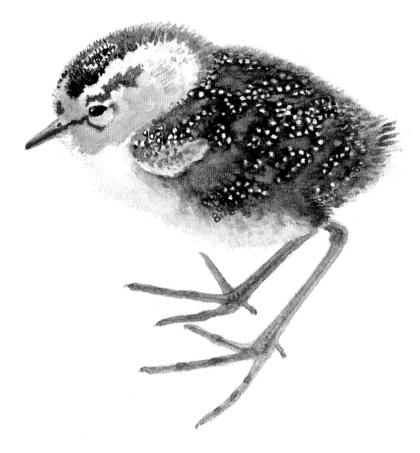

Erolia fuscicollis one day old direct from life
Jenny Lind Island, Queen Maud Gulf
Hatched July 12, 1962 at Cambridge Bay
and painted July 13

Reproduced 1.54 x original

Plate 5

19

Plate 6

Yellow-billed Cuckoo (*Coccyzus americanus*)

The "rain crow"—so named because it often calls as the sky darkens prior to rain—may seem to many who grew up in the rural Midwest to be an almost mythical bird. People can often remember having heard it as youngsters but, never having seen it, eventually come to wonder whether such a bird actually exists. This experience is so commonplace in Nebraska that I can often tell someone the name of the bird species involved before his or her story progresses far. Cuckoos of many species, especially the more than fifty brood parasites that lay their eggs in the nests of exploited host birds, are notoriously elusive and difficult to observe. These birds often adopt a nearly erect and entirely motionless attitude when alarmed. Like some owls and nightjars, alarmed cuckoos may even partly close their eyes to avoid detection. The just-feathered juvenile Sutton painted exhibits a crouching posture and appearance that definitely mark it as a cuckoo, but the wide-eyed bird nevertheless seems to project a distinct sense of self-confidence and curiosity.

In *Birds Worth Watching*, Sutton speculated that the newly feathered juveniles of the two North American species of cuckoos might differ slightly in their back coloration and especially in their mouth-lining colors; the yellow-billed species has a red gape, with several con-trasting yellow palatal spots, and the black-billed cuckoo juvenile's gape in Sutton's opinion is probably yellow to orange instead. The point seems minor but may have significance in terms of the potential in these two species for attaining success with interspecific brood parasitism.

Both species lay bluish eggs of nearly the same size and color, and besides laying eggs in the nests of other kinds of birds, they may lay in their own nests and have occasionally been known to parasitize each other's nests. The success of the two species as parasites is still uncertain. A bright red nestling gape color is common among some of the obligate brood parasites of the cuckoo family (those that never build their own nests) and probably serves as a strong social signal for stimulating feeding by host parents. A marked difference in nestling mouth-lining colors might thus play a significant role in influencing parental acceptance of foster young by each of the two species and might affect the success of either or both as to their acceptance by the other species.

Suggested Reading: Sutton, 1949 (painting of juvenile); Bent, 1940, (pp. 54–70, general biology); Hamilton and Orians, 1965 (breeding biology); Johnsgard, in press (brood parasitism); Potter, 1980 (breeding biology); Preble, 1957 (breeding biology).

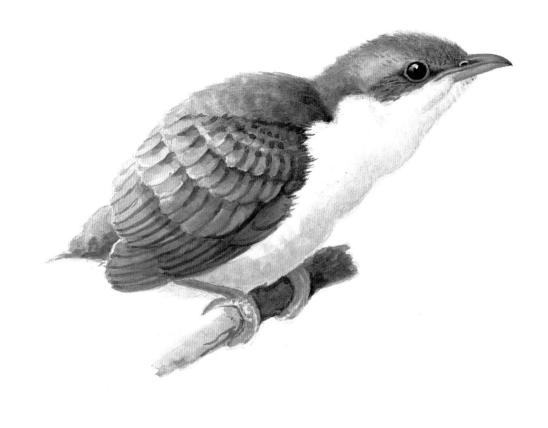

...Koo law d from life
artoredun, Aun. Arbo—
June 24, 1948
Note Pollen ⌗

Reproduced .96 x original **Plate 6**

Plate 7

Horned Lark
(Eremophila alpestris)

While hiking across an area of sand dunes during a field trip at a biological station in western Nebraska a decade or more ago, I suffered an ornithologically embarrassing moment. There, walking about on the dune not far away, were three or four small birds that seemed somewhat familiar but nevertheless lacked obvious field marks, other than having unusually short tails. As my students waited expectantly for an instant identification from me, I frantically and repeatedly ran down a mental list of possible candidates but kept coming up with nothing. Suddenly, an adult horned lark unexpectedly appeared on the scene. I finally realized that these birds were a brood of juveniles that, like the one Sutton illustrated, still lacked the distinctive facial markings and the long, white-edged black tail that serve to identify adults so easily.

Horned larks are amazingly adaptable birds, breeding in arctic and alpine tundra, on the low-stature prairie grasslands of the interior Great Plains, and on the desert grasslands of the arid Southwest. They have been estimated to be one of the commonest breeding birds on North Dakota's glacial-till prairies, and in the Nebraska Sandhills they likewise are easily the most commonly seen bird species as one travels the sandy roads that cross this semiwilderness grassland region. As I write this in mid-June, I have just returned from a day-long trip into these very Sandhills, and my freshened memories of hundreds of horned larks suddenly materializing from the roadside and scattering like leaves on either side of the car are just as powerful as are my lingering mental images of upland sandpipers balancing ballerina-like on fenceposts, the sky-dances of dozens of territorial male lark buntings, and two long-billed curlews outlined against the crest of a curving sand dune horizon, their bills incongruously long and yet also providing a perfect touch for such royal grassland birds. In the Sandhills the abundant horned larks provide a kind of reliable avian peasantry, their delicate colors and beautiful vocalizations too easily overlooked; many people driving through these grasslands are perhaps inclined to assume that all such small, dun-colored birds are "just sparrows."

Like the other true larks (such as the famous skylark), male horned larks also sometimes perform wonderful aerial song displays, but much courtship singing is also conducted from the ground. The nest, constructed by the female, is a simple ground scrape, and the juveniles typically leave the nest while they are still unable to fly. It was such a family of newly fledged birds that my students and I had chanced upon.

Suggested Reading: Beason and Franks, 1974 (breeding biology); Bent, 1942, (pp. 320–71, general biology); Verbeck, 1967 (breeding biology).

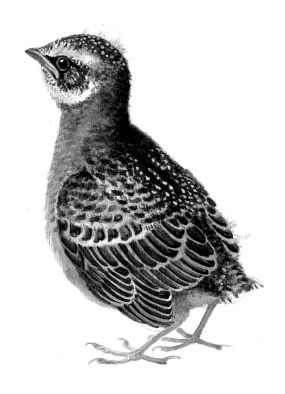

Prairie Horned Lark direct from life
June 22, 1948, Ann Arbor, Mich.
H. B. Tordoff

Reproduced original size

Plate 7

Northern Cardinal
(Cardinalis cardinalis)

George Sutton was fond of keeping birds as household pets and wrote of various such experiences in his popular articles. Among the many birds he raised were two female northern cardinals, or "redbirds." Sutton began his long-term adventure with these birds in early August, 1936, when he found a nest with a trio of three- to four-day-old chicks, their pink skins easily visible through their still inadequate covering of fuzzy grayish down. Of the three birds, two proved to be females and one, the smallest, was a male. Sutton named the larger female Crousty (a term people of the eastern Canadian arctic use to describe ill-tempered dogs), and the smaller female he called Second Place. Four days after finding them, Sutton revisited the nest and removed the three nestlings to a cage at the E. S. George Reserve in southeastern Michigan. There he could study their individual development under controlled conditions and could record their plumage changes and molting patterns. He was especially eager to follow the plumage changes in the male during its first few months of life.

Sutton evidently first painted two of his charges on August 10, when they were seven or eight days old and their faces reflected the expression of "an unresponsive bulldog." Pinfeathers on their crowns marked where their crests would be. The next day he placed metal bands on their legs to identify them individually and found that Crousty was the heaviest, at twenty-five grams. The lightest unfortunately died from a mite infestation the following day, thus destroying Sutton's hopes of studying male plumage changes. Crousty jumped out of her artificial nest the next day, to be followed by her smaller sister about a day later, namely at about twelve days of age. In few days both were flying short distances but, with only stubby tails, their flying abilities were limited at best, and crash landings or collisions with solid objects such as windowpanes were everyday occurrences. Both females survived to molt into their adult plumages. Eventually Crousty attracted the attention of a wandering wild male northern cardinal (the species was then rare in the Ithaca area, where Sutton took her) and abandoned her human-oriented life for good.

Although her first nesting attempt was a failure, and her second clutch of eggs proved infertile, her third effort of the summer was a success, with two chicks fledging from her clutch of three eggs. Crousty's remarkable life came to a tragic end in 1939, when she was shot by a thoughtless youngster, who, as an observer later reported, surreptitiously buried her remains after noticing the metal Department of Interior band on her leg. However, as Sutton noted, Crousty's progeny

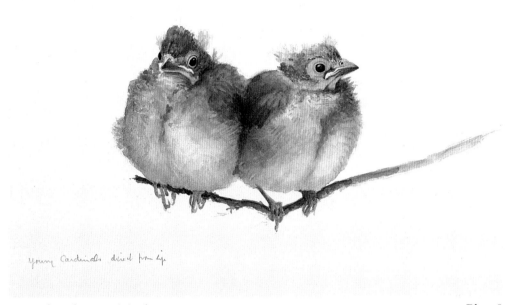

young Cardinals dried from life

Reproduced .77 x original Plate 8

survived, and "thus established the Red-bird tribe in the Ithaca region." Little did I know, when I attended graduate school at Cornell some twenty years later and came to know and love the cardinals there (their range then did not extend north to my boyhood home in North Dakota), that I owed this pleasure in no small part to the efforts of George Sutton and Crousty.

For a brief period before Crousty managed to bring off a brood of her own young, she and her mate temporarily adopted a young brown-headed cowbird that had evidently abandoned its "dull, plodding" vireo foster parents in favor of more attractive food providers in the form of these cardinals. Although in Sutton's Michigan studies of cardinals he judged cowbirds to be of minor significance (only two cowbird eggs were present among the twenty-one cardinal nests he found), such is not the case in the Great Plains. As he wrote in *Birds Worth Watching*, "In Oklahoma the cardinal is unquestionably the leading producer of cowbirds." The birds present easy targets for cowbirds, partly because the eggs of the two species are so similar in size and color but also because cardinals are such indulgent parents, seemingly willing to feed almost any dependant. According to Sutton, cardinals have even been observed feeding goldfish at the edge of an outdoor pool!

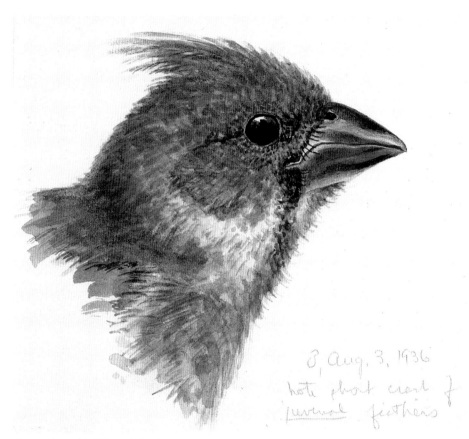

♂, Aug. 3, 1936
note about crown of
juvenal feathers

Reproduced 1.57 x original

Plate 9

Sutton found in his Michigan research that twenty-one cardinal nests under observation produced fifty-eight eggs, of which twenty-nine hatched successfully. At least nine of these young later fledged; another nine might also have fledged but their fate was not documented; and six (including Crousty and her siblings) were taken into captivity for study. Thus, fledging success in wild cardinals, as in other birds, is usually surprisingly low, but by repeated nesting efforts through the summer (perhaps as many as three), most pairs probably eventually manage to fledge at least a few offspring. No doubt predators such as Cooper's hawks are serious enemies for the newly fledged young, most of which probably do not survive long enough to nest the following spring.

Suggested Reading: Sutton, 1935 (juvenal plumage), 1941a (Crousty account), 1943 (behavior), 1959 (pt. 3, pp. 77–101, breeding biology); Bent, 1968 (vol. 1, pp. 1–15, general biology); Conner et al., 1986 (breeding biology); Johnsgard, in press (brood paratism); Ritchison, 1988 (song repertoires).

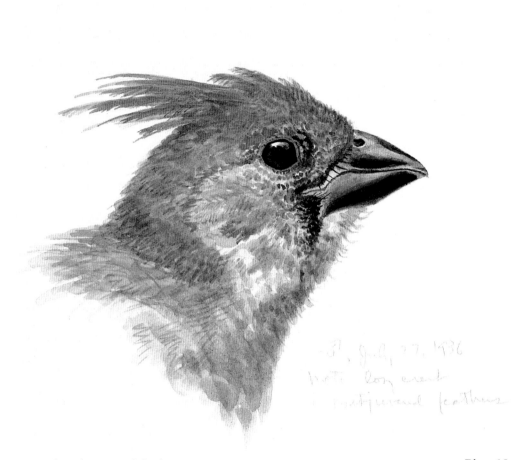

Reproduced 1.77 x original

Plate 10

29

Rose-breasted Grosbeak
(Pheucticus ludovicianus)

Rose-breasted grosbeaks are among the most beautiful representatives of the North American sparrow family, the males rivaling male northern cardinals for sheer exuberance of color and cheerfulness of song. Sutton observed that in addition to their massive beaks they are similar in some other respects to northern cardinals, but grosbeaks are longer-winged, more migratory, and in all plumages except for the male's breeding plumage are more heavily streaked than are cardinals. Additionally, the grosbeak has white natal down and an incomplete postjuvenal molt during its first fall, involving only its body feathers, both sexes developing a first-winter plumage that is like the adult female's. The cardinal has gray natal down and a complete post-juvenal molt into its first-winter plumage, involving its wing and tail feathers as well and producing a plumage appearance essentially identical to that in older adults. Among differences in behavior, song is prominent. The female cardinal sings frequently and loudly, but the grosbeak female sings only occasionally and with reduced volume. In contrast, the male grosbeak sings frequently while assisting in incubation, whereas the male cardinal never helps incubate at all.

Few grosbeaks nested on the E. S. George Reserve during Sutton's studies there, and only two nests were located (one outside the reserve boundary) during the entire period from 1935 to 1948. Nests are usually less than twenty feet above ground, in fairly open deciduous forests such as along floodplains or on upland slopes. Along the Platte River of eastern Nebraska the rose-breasted grosbeak is a common summer breeder; its arrival in late April usually occurs just as the woodland oaks, elms, and other hardwood trees are leafing out, and morel mushrooms are sprouting up in their litter. Farther west along the Platte there is a rather broad zone of hybridization with the black-headed grosbeak, and at our biological field station near Ogallala the black-headed grosbeaks currently predominate numerically in the overall grosbeak population. Some obvious hybrids do occur here, but the major hybrid zone must still occur in the central Platte valley, as was true in the 1950s when David West first studied it. There are few if any noticeable differences in the habitat requirements of the two species. Studies in North Dakota have indicated that the courtship behaviors of the two are also similar, and plumage

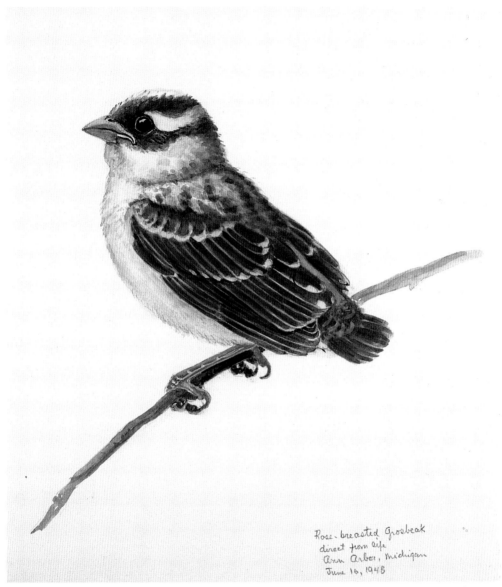

Rose-breasted Grosbeak
direct from life
Ann Arbor, Michigan
June 16, 1948

Reproduced at original size

Plate 11

31

color differences between males of the two species may be important in species recognition. Territorial males usually do not discriminate between the songs of their own and the other species but do respond differentially when mounted males of the two species are presented to them.

Suggested Reading: Sutton, 1959 (pt.3, pp. 77–101, breeding biology); Bent, 1968 (vol. 1, pp. 36-55, general biology); Kroodsma, 1970 (breeding behavior and hybridization); West, 1962 (hybridization).

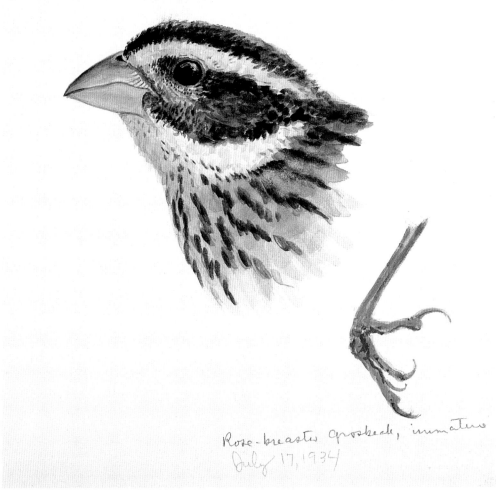

Rose-breasted grosbeak, immature
July 17, 1934

Reproduced 1.3 x original

Plate 12

Indigo Bunting
(Passerina cyanea)

Sutton's observations of indigo buntings in southeastern Michigan were extensive: there the species is not only common but also among the most conspicuous of the breeding birds. The males sing endlessly, including during the hottest summer days. Even males feeding unfledged birds spend much of their time in song, waiting for their brooding mates to arrive and collect mouthfuls of insects to feed to their waiting nestlings rather than delivering food to the chicks directly. Nevertheless, a male may eventually take sole charge of the pair's first brood, allowing his mate to begin a new nesting effort. Evidently the female constructs the nest alone, whether or not her mate is available. During his many summers of field study on the E. S. George Reserve near Ann Arbor, Sutton located a total of 108 indigo bunting nesting territories and found twenty-six nests. These nests produced at least forty-four hatched bunting chicks, plus three cowbird babies from four parasitized nests. Twenty-six of the buntings and none of the cowbirds fledged.

Around our biological field station in southwestern Nebraska, the indigo bunting is near the western limit of its range. Similarly, the lazuli bunting is at the extreme eastern limit of its range. In some years, such as in 1996, indigo buntings are virtually the only species to be found, whereas in 1995 lazuli buntings

were easily the commoner breeding species around the station. In still other summers the territorial males nearest the station lodge were obviously mostly hybrids, their strange appearance and varied songs frustrating my beginning ornithology students greatly. While frantically trying to learn simple field-identification clues for all the local species before the next field quiz, students do not seem to be entranced by the unique biological events occuring around them. Interestingly, the blue plumage color of the male does not always provide certain field identification of these buntings; because this perceived sky-blue color depends on directed light refraction from the plumage surface, under conditions of heavy overcast the male may appear to be a dingy grayish color overall. This can cause cries of anguish and disbelief among students who imagine that male indigo buntings should invariably be a gorgeous blue regardless of lighting conditions, and who have thus guessed that a bird they were asked to identify under cloudy skies was some inconspicuous kind of sparrow or finch.

Hybridization in the vicinity of our field station and elsewhere in western Nebraska is fairly commonplace; the two bunting species seem to have similar habitat requirements—forest-edge vegetation containing shrubs, low trees, and herbaceous plants. In some areas of overlap, males of

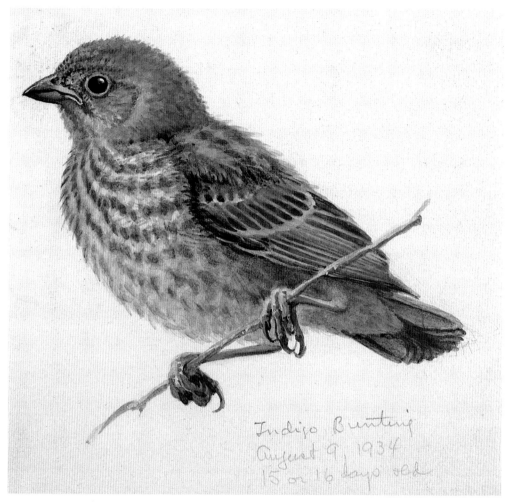

Reproduced 1.46 x original

Plate 13

the two species seemingly can differentiate between their own kind's vocalizations and those of the other species, but in other areas, such differentiation is not present, and males respond to recorded playbacks of the songs of either species. Such diversity of response indicates that learning may play an important role in vocal species recognition behavior.

Suggested Reading: Sutton, 1935 (juvenal plumage), 1943 (behavior), 1959 (pt. 3, pp. 77–101, breeding biology); Emlen, Rising and Thompson, 1975 (hybridization); Kroodsma, 1970 (hybridization); Payne, 1992 (general biology); Sibley and Short, 1959 (hybridization); Westneat, 1988 (male breeding behavior).

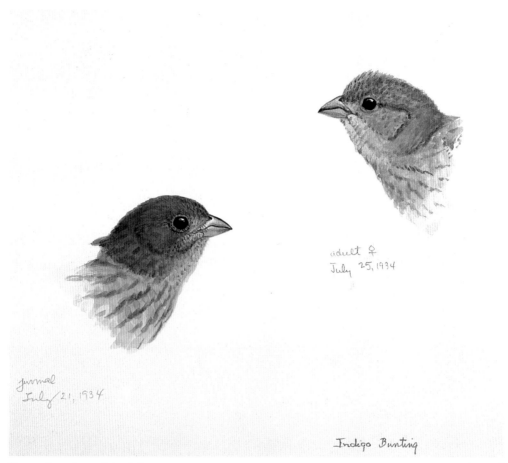

juvenal
July/21, 1934

adult ♀
July 25, 1934

Indigo Bunting

Reproduced at original size

Plate 14

Eastern Towhee
(Pipilo erythrophthalmus)

This is one of several species of North American birds for which the Latin name (in this case roughly translating as "red-eyed sparrow") has long remained unchanged while the officially designated English name has varied greatly. From the 1950s until 1996, both the eastern population of towhees (birds having unspotted black upper parts) and the western form (which has white spots on the black or brown shoulder area, and larger wing coverts) were known by the American Ornithologists' Union as rufous-sided towhees; they were thereby implicitly considered as representing two races of a single species. Earlier in the century the eastern population of towhees had been known as the red-eyed towhee, but the western population was regarded as a distinct species and was called the spotted towhee. Such is the case once again, now that the younger taxonomic "splitters" in the AOU are in apparent philosophic ascendancy over the now aging "lumpers," who tend to consider biological information more significant than molecular genetic data when evaluating species limits.

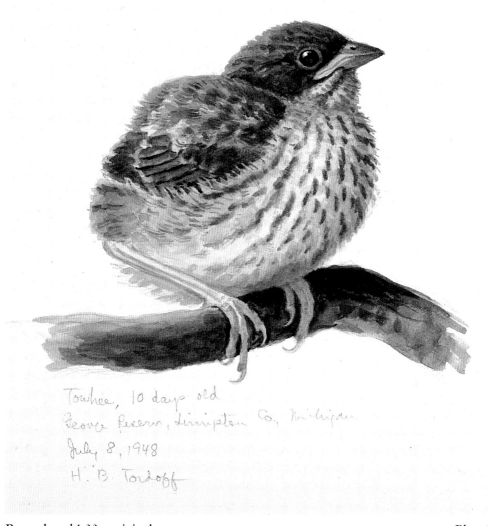

Towhee, 10 days old
George Reserve, Livingston Co., Michigan
July 8, 1948
H. B. Tordoff

Reproduced 1.33 x original

Plate 15

The confusion associated with this annoying and frequent name changing results from the failure of these birds to follow the standard biological definition of a species. A major component of the traditional species definition involves the idea of reproductive isolation preventing significant amounts of hybridization with individuals of all other species, at least under natural conditions. "Failure" of reproductive exclusivity as in towhees is also evident among several other widely ranging species that similarly hybridize regularly along a narrow to fairly broad biological suture zone that extends in a roughly north-south direction across the western parts of Oklahoma, Kansas, Nebraska, and the Dakotas. The eastern and western meadowlarks, the indigo and lazuli buntings, and the rose-breasted and black-headed grosbeaks all offer somewhat similar examples of this same phenomenon. Members of these species pairs all differ considerably in male plumage and courtship behavior, or have differing song traits in regions well to the east and west of the Great Plains, but nevertheless hybridize locally where they come into contact, usually along wooded river valleys that transect these arid plains. For example, towhees are abundant around the University of Nebraska's biological field station, located along the North Platte River near Ogallala. There the birds often exhibit small white back spotting, and instead of singing the typical eastern towhee's song, *drink your teaaaaaaaaa*, males are just as likely to produce the western towhee's more varied and seemingly more uninhibited version, which in sanitized form often is transliterated as *drink your goldarned teaaaaaaa*.

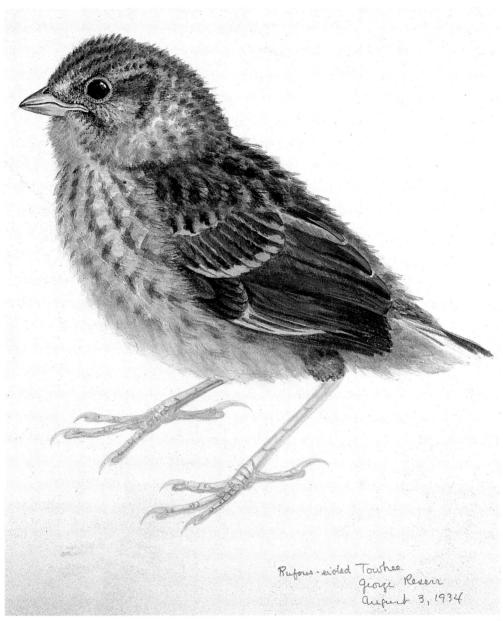

Rufous-sided Towhee
George Reserve
August 3, 1934

Reproduced 1.21 x original Plate 16

Sutton's fieldwork in southeastern Michigan revealed that the birds were absent from those oak-hickory forest areas where a lack of forest-floor leaves made their foot-scratching method of foraging unproductive. He found a total of twelve nests over his eight years of study, of which seven were found with eggs. Only three of these nests fledged any young, and in one case the sole bird to fledge was a cowbird. Evidently the nests were easily found by nest predators such as blue racers, and only by double- or even triple-clutching were the birds likely to stand a good chance of producing any fledged offspring.

Suggested Reading: Sutton, 1935 (juvenal plumage), 1959 (pt. 4, pp. 127–51, breeding biology); Bent, 1968 (vol. 1, pp. 562–83, general biology); Sibley and West, 1959 (hybridization).

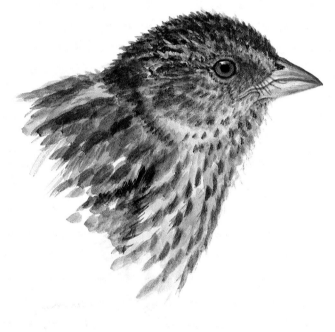

Juvenal
July 18, 1934

Rufous-sided Towhee

Reproduced 1.27 x original

Plate 17

43

Chipping Sparrow
(Spizella passerina)

Sutton once pointed out that although the juvenal plumages of the chipping sparrow and field sparrow are nearly identical and anatomically they are similarly hard to separate, the two species also show significant behavioral differences. For example, chipping sparrows rarely nest on the ground and almost invariably line their nests with hair, whereas field sparrow nests are most likely to be on the ground and are typically lined with fine grasses. The accelerating "bouncing ball" song of the field sparrow is somewhat more melodious than are the much more mechanical song notes of the chipping sparrow, and while the male field sparrow usually sings from the highest available perch it can find, such as a tall bush or sapling, the chipping sparrow always sings from hidden arboreal perches. Yet, more people probably learn to recognize the jaunty-looking chipping sparrow, with its distinctive chestnut cape and the contrasting white racing-stripe line above its eyes, than the relatively plainly colored field sparrow. Furthermore, chipping sparrows are much more likely to become familiar visitors at city or suburban bird feeders than are field sparrows.

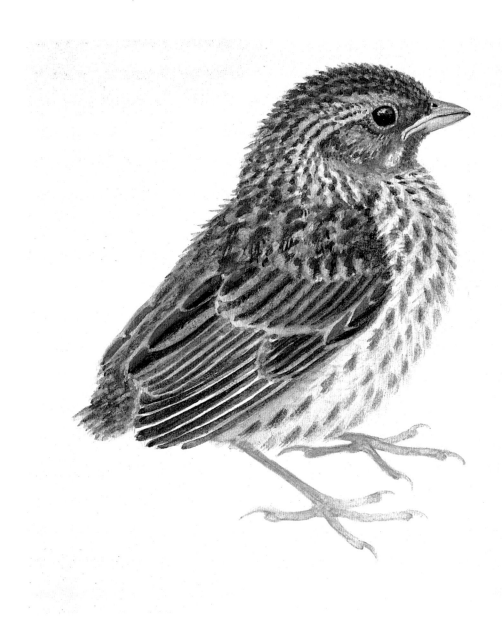

Reproduced 1.94 x original

Sutton found many chipping sparrow territories (which average less than an acre in area) and nests during his years of fieldwork at the E. S. George Reserve in southeastern Michigan. Of thirty-eight nests he found, only one contained a cowbird egg, which is rather remarkable considering the high level of cowbird parasitism of chipping sparrows reported elsewhere, such as in New York State. However, the nests in the George Reserve tend to be well concealed in junipers and thus are somewhat protected from cowbirds as well as from nest predators.

The nest is constructed entirely by the female, although the male may accompany her during material-gathering activities. Generally, three- or four-egg clutches are laid, with four-egg clutches becoming rarer as the summer progresses. Double-brooding (rearing two broods successively

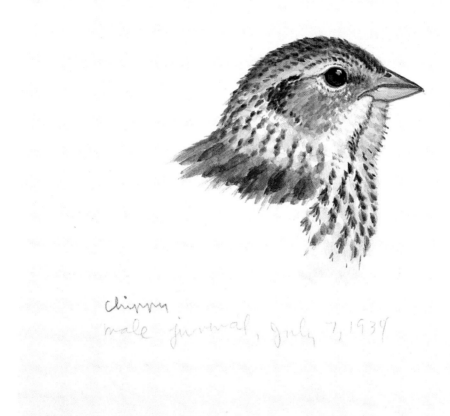

chippy
male juvenal, july 7, 1934

Reproduced 2.0 x original

Plate 19

in the same season) evidently occured in Sutton's study area and has been reported as the usual pattern elsewhere. On average, more than half of the chipping sparrow nests studied in Michigan and elsewhere successfully hatch one or more young, judging from various studies. In part this favorable success rate must reflect the skill of the parents in coping with the problems created by cowbirds, snakes, and other predators, besides such uncontrollable mortality factors as parasites and diseases.

Suggested Reading: Sutton, 1935, 1937 (juvenal plumage), 1960 (pt. 6, pp. 46–65, breeding biology); Bent, 1968 (vol. 2, pp. 1166–82, general biology); Reynolds and Knapton, 1984 (breeding biology); Rising, 1996 (natural history).

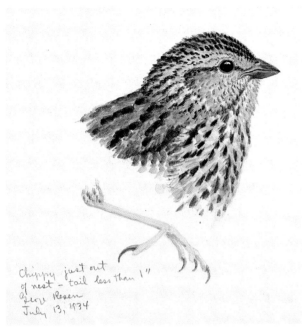

Chippy just out
of nest – tail less than 1"
George Rosen
July 13, 1934

Plate 20-a

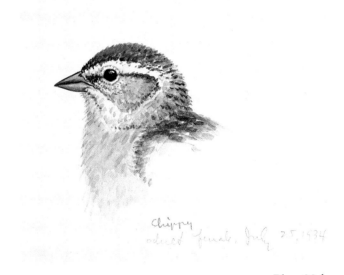

Chippy
adult female, July 25, 1934

Plate 20-b

Both plates reproduced at original size

Plate 21

Field Sparrow
(Spizella pusilla)

From my cabin at our university's biological field station in southwestern Nebraska I can hear field sparrows calling almost every summer morning and evening, the males' song having a cadence exactly like that of a bouncing ping-pong ball gradually coming to a stop. Once this similarity has been pointed out, the field sparrow's song is one of the few vocalizations my students rejoice on hearing during field quizzes. It is one of the most easily remembered of all bird songs, although on occasion I have had "ping-pong bird" written on quiz cards by students hoping for at least a fractional point of credit for their efforts.

In his studies on the E. S. George Reserve, Sutton found field sparrows to be the most abundant breeding bird species. Old, weedy fields with scattered saplings or tall shrubs are its favored habitat, but it rarely also extends to more heavily shaded woodland types. Over his eight years of study, Sutton observed fifty-nine active nests, nearly all of which were elevated somewhat above the ground, but none was placed higher than sixty inches above the substrate. A total of only thirty-seven young were fledged successfully from the nests under observation, although Sutton eventually released another six juveniles that he had removed from their nests for his plumage studies. Of the fifty-nine nests, eleven had been parasitized by cowbirds, which are a serious threat to the reproductive success of field sparrows over most of their common ranges. Other studies across the country, and especially those from the interior grasslands region, clearly indicate that cowbirds often do great damage to nesting field sparrows. Apparently the presence of the larger cowbird egg, which the sparrows are unable to remove, may cause them to abandon their nest, leaving behind their own eggs as well as the cowbird's. Louis Best found that 403 field sparrow eggs in 147 nests produced only forty-five fledged young, these distributed among fifteen nests. In this study nest predation by snakes was apparently a more serious threat to breeding success than was cowbird parasitism.

Suggested Reading: Sutton, 1935 (juvenal plumage), 1943 (behavior), 1948 (hand-rearing), 1960 (pt. 6, pp. 46–65, breeding biology); Bent, 1968 (vol. 2, pp. 1217–36, general biology); Best, 1977a, 1977b, 1978 (breeding biology); Nelson and Croner, 1991 (song functions); Rising, 1996 (natural history).

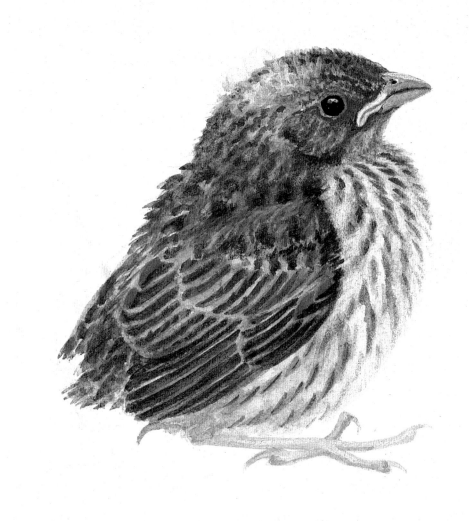

Reproduced 2.05 x original Plate 21

Vesper Sparrow
(Pooecetes gramineus)

One of the first sparrows I learned to identify as I was growing up in North Dakota during the dry years of the mid-1930s was the vesper sparrow, easily seen along the dusty country roads and readily identified by its long, white-edged tail. I had no field guide, nor did I know of the existence of the then newly published field guide to eastern birds by Roger Tory Peterson. However, our local library had a set of T. S. Robert's classic two-volume *Birds of Minnesota*, always strictly kept in the library's reference section and thus under the watchful eyes of the librarian. These wonderfully illustrated volumes became a kind of ornithological bible for me, allowing me to learn to identify many wonderful birds that I never imagined I would be able to see in life as well as such common birds as the vesper sparrow. In recent years on return trips to that library I have regularly looked for that magnificent pair of books, just to be certain they were still safely there. On my most recent visit they had finally disappeared from the shelves and from the card file, some seventy years after they were published. I would dearly like to believe that they departed during a library sale of outdated books and now occupy some youngster's bookshelf.

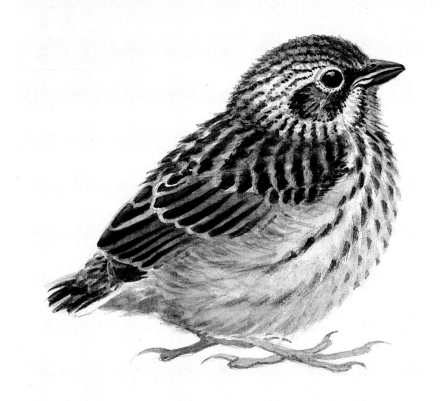

July 17, 1935

Reproduced 1.35 x original

Plate 22

The vesper sparrows that were then and still are such commonplace birds in North Dakota reach the southern edge of their range in the Nebraska Sandhills, where they are much rarer than one would imagine. George Sutton identified as one of the most important habitat components of vesper sparrows a site suitable for taking dust baths. Sandy roads or bare-ground openings in low-stature grasslands or weed-choked fields are their ideal choices for taking summer dust baths; no standing water is apparently needed by these drought-tolerant birds. The birds establish relatively large territories in their low-stature habitats, the territories perhaps averaging from eight to twelve acres in area, within which scattered singing perches such as trees, posts, or shrubs are also invariably present. Vesper sparrows sing only rarely from the ground or while in flight, but their singing continues all day long and at times past sunset, making the species' vernacular name seem especially appropriate. The nest is built on the ground, sometimes fully exposed to view but more often shaded by a weed, a clump of grass, or other low vegetation.

Sutton found eleven active vesper sparrow nests during his years of study at the E. S. George Reserve, with nests generally widely separated (a minimum of about forty yards apart), and singing posts of adjoining males separated by sixty to two hundred yards. Of the thirty-two eggs present in these nests, at least seventeen hatched and a minimum of three chicks (possibly as many as ten) fledged. Additionally, Sutton removed three chicks for laboratory study and rearing. No cowbird eggs were found in any of these nests, but Sutton observed one cowbird youngster being fed by an adult vesper sparrow.

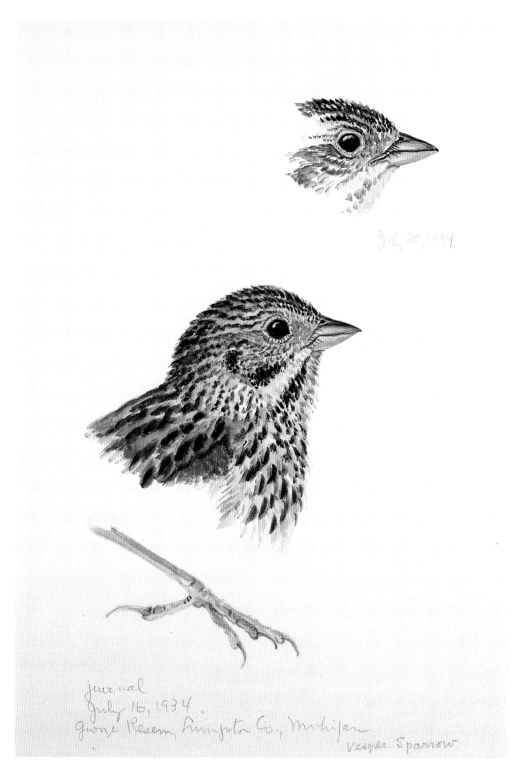

juvenal
July 16, 1934.
Game Reserve, Livingston Co., Michigan
Vesper Sparrow

July 20, 1934

Reproduced 1.39 x original

Plate 23

One of the vesper sparrows Sutton raised, which he named Vessie, he caught when the chick had just fledged and was about two weeks old. Being larger and older than his cagemate Grassy (a grasshopper sparrow), Vessie could eat larger, more fully developed grasshoppers than could Grassy, but the two survived each other's company well. While Grassy spent much of his time chasing small grasshoppers, Vessie would lie on his belly on the porch, engaging in long sunbaths, often singing contentedly to himself in barely audible tones. In Sutton's words, his song "was a soliloquy about warm air and waving grass and summer's slow ebbing."

Suggested Reading: Sutton, 1935 (juvenal plumage), 1941b (juvenal plumage), 1943 (behavior), 1948 (hand–rearing); Bent, 1968 (vol. 2, pp. 868–81, general biology); Best and Rodenhouse, 1984 (territoriality); Rising, 1996 (natural history); Wray et al., 1982 (breeding success); Wray and Whitmore, 1979 (nesting success).

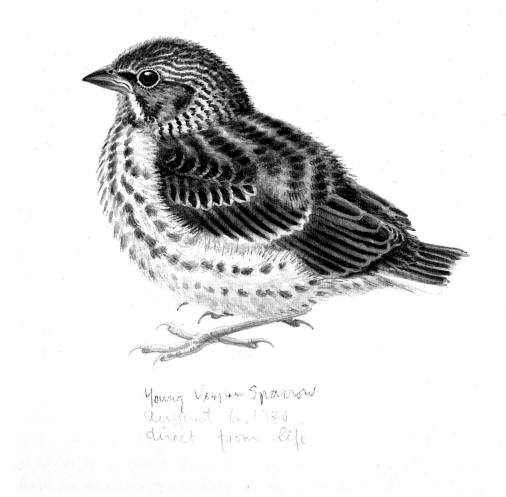

Young Vesper Sparrow
August 6, 1980
direct from life

Reproduced 1.2 x original

Plate 24

Savannah Sparrow
(Passerculus sandwichensis)

The vernacular name of the Savannah sparrow refers neither to the Savannah River nor to the bird's preferred grassland habitat but rather to the city of Savannah, Georgia, where the type specimen (on which the species' description was initially based) was collected. Although this city is now certainly not typical Savannah sparrow habitat, it is a beautiful name and, by sheer chance, brings to mind the grassy lowland habitats that this species favors. My university's biological station lies somewhat south of the known southern breeding limits of this species, and so it was with considerable excitement that we caught and banded our first Savannah sparrows a few summers ago. After catching the first specimen in a watery, weed-choked ditch, we initially thought we might have captured a rare sharp-tailed sparrow, since the head plumage was unusually yellow toned. That would have been cause for an even greater celebration, but various measurements and plumage features eventually confirmed the captured bird to be a Savannah sparrow, only slightly displaced from its known nesting range.

Savannah sparrows have streaked breasts, rather short tails, and, especially during the breeding season, a variably yellow cast to the front portion of their superciliary stripes, which extend from the base of the bill back above the eyes. Similar yellow markings also occur in grasshopper sparrows, and adults of both species have some yellow present at the bend of the wing. The amount of yellow present on the head is highly variable seasonally, and Sutton believed that two discernible color phases may exist among juveniles, with some individuals being quite drab and others having a good deal of yellow present on both the upper and underparts.

On the E. S. George Reserve, Sutton found Savannah sparrows to be distinctly birds of open country, nesting only on an area of treeless pastureland. Yet other biologists may associate it with such diverse habitats as coastal grasslands, arctic tundra, the cool mountain meadows of the Teton Range (where I best remember seeing it), or still other grass-dominated habitats having a rather open vegetational structure and areas of bare ground available for birds' foraging activities. Savannah sparrows thus occupy grasslands similar to those favored by such other species as vesper sparrows, grasshopper sparrows, and Henslow's sparrows and probably overlap ecologically with each of these somewhat. Surprisingly, hybridization has been reported with the grasshopper sparrow, which is regarded as belonging to a quite different avian genus.

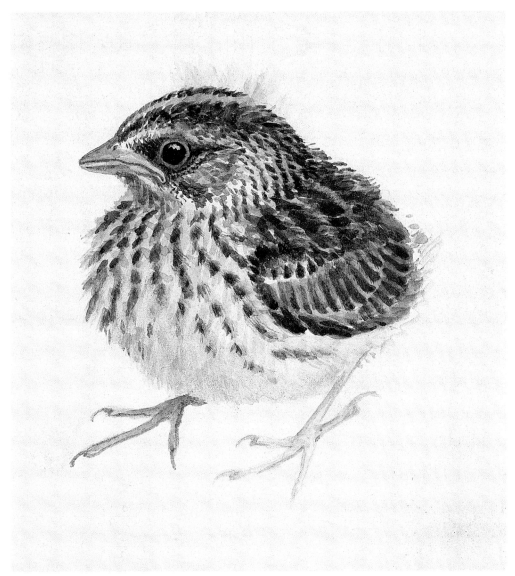

Reproduced 2.17 x original

Plate 25

Breeding territories of Savannah sparrows are rather small (averaging only about a quarter-acre in one study), and nests are typically hollowed out, grass-lined scrapes, usually placed in rather thick vegetation so as to conceal them from overhead view. Although most males are probably monogamous, polygynous mating was observed in three of thirteen territory holders in a Nova Scotia study. The eggs differ from those of most grassland sparrows in that they are often scrawled rather than simply spotted with browns and blacks. Four or five eggs constitute the usual clutch, with repeat clutches—double-brooding is regular—often smaller than the initial effort. Cowbird parasitism is relatively infrequent in this species.

Suggested Reading: Sutton, 1935 (juvenal plumage), 1959 (pt. 4, pp. 127–51, breeding biology); Dickerman, 1968 (hybridization with grasshopper sparrow); Dixon, 1978 (breeding biology); Rising, 1996 (natural history); Welsh, 1975 (breeding biology); Wheelright and Rising, 1993 (general biology); Wray et al., 1982 (breeding success).

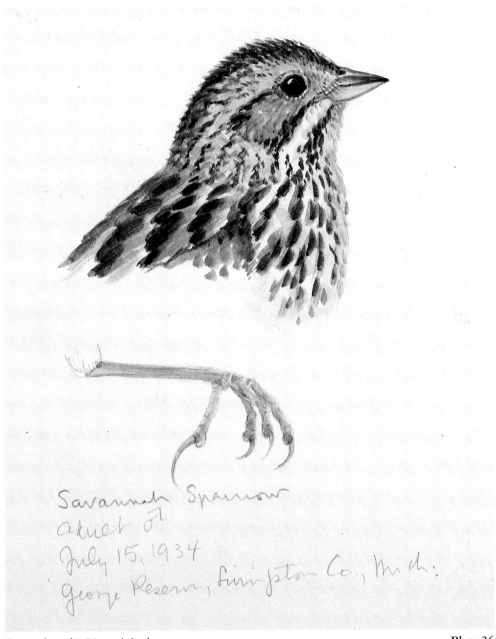

Savannah Sparrow
adult ♂
July 15, 1934
George Reserve, Livingston Co., Mich.

Reproduced 1.59 x original

Plate 26

Grasshopper Sparrow
(Ammodramus savannarum)

The grasshopper sparrow is perfectly named: not only does it eat grasshoppers almost exclusively, but the male's territorial song even *sounds* almost like a grasshopper's stridulation. I have often wondered if this insectlike song of the grasshopper might be an antipredator adaptation, or whether the sounds are simply serendipitously similar. In recent years my upper-register hearing has declined to the point that the high-pitched grasshopper sparrow notes are just beyond my perception, unless the birds are very close. This is unfortunate for my students, since most grasshopper sparrows refuse to show themselves except when singing, and thus I generally overlook their presence. Yet they are extremely common in the Nebraska Sandhills, and a glimpse of any tiny sparrow hiding in the grass is most likely to reveal the striped head, streaked back, and short tail of the grasshopper sparrow. Its bill is heavy and seems slightly too large for the rest of its head, producing a flat-headed and "Roman-nosed" effect that renders the bird slightly less attractive than would otherwise be the case. Sutton once described it well as a "sharp-tailed, rounded-winged, and rather coarse-billed finch."

Sutton also observed that the juvenal plumage of the grasshopper sparrow is unusual in at least two respects. First, in common with the northern cardinal and Henslow's sparrow, this species has a complete postjuvenal molt, involving both wing and tail feathers, prior to assuming its initial breeding plumage the following spring. Second, the distinctive yellow spot found in adult grasshopper sparrows is lacking in juveniles and appears only during the first winter, and the juvenile's underparts are not buffy as in adult grasshopper sparrows but instead are quite heavily streaked, as in Savannah sparrows. For these reasons I initially had some difficulty in identifying which of Sutton's unlabeled paintings of these two birds represented which species.

Nests of grasshopper sparrows tend to be extremely well hidden and thus difficult to locate. Sutton found only eight active nests in his years of study on the E. S. George Reserve, all but one of which were on the ground. Perhaps as many as four chicks fledged successfully from these nests; none was parasitized by cowbirds. The low incidence of cowbird parasitism probably is a reflection of how well hidden the nests usually are.

One of Sutton's favorite baby birds was a grasshopper sparrow chick that he called Grassy, caught as a nine- or ten-day-old chick, just as he was gaining his initial flying abilities. After a day of obstinate fasting, he began to eat as if famished, eating hundreds of fresh, tiny grasshopper nymphs every day. Grassy eventually

62

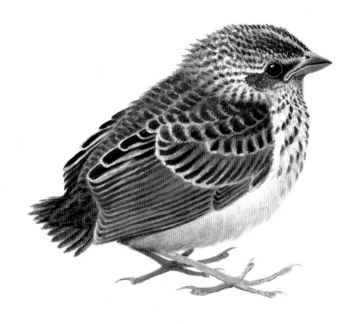

Grasshopper Sparrow
George Reserve, Pinckney, Mich.
July 13, 1935

Reproduced 1.07 x original Plate 27

learned to catch his own grasshoppers when they were released on a porch and apparently took delight in harassing the larger vesper sparrow in residence, Vessie. Grassy soon became boss of Sutton's "sparrow ranch," also socially dominating three young field sparrows, four Henslow's sparrows, and a single song sparrow.

Suggested Reading: Sutton, 1935, 1936 (juvenal plumage), 1959 (pt. 4, 127–51, breeding biology), 1948 (hand–rearing); Bent, 1968 (vol. 2, pp. 725–45, general biology); Dickerman, 1968 (hybridization with Savannah sparrow); Rising, 1996 (natural history); Smith, 1959 (songs).

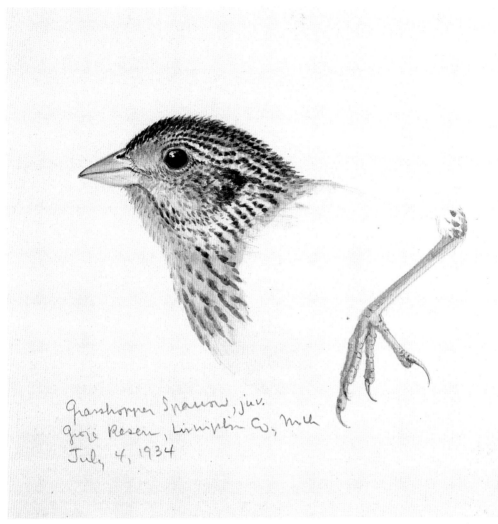

Grasshopper Sparrow, juv.
Gross Reserv., Livingston Co., Mich.
July 4, 1934

Reproduced 1.57 x original

Plate 28

Henslow's Sparrow
(Ammodramus henslowii)

Southeastern Nebraska is at the western-most limit of Henslow's sparrow breeding range, although not far to the south in the Flint Hills of Kansas the species is a fairly regular breeder. A few years ago I spent nearly fifteen minutes repeatedly stalking an elusive grassland sparrow that I thought was probably a Henslow's, but in the end it managed to elude me without ever showing enough of itself for me to identify it with any degree of certainty. To date I have never been able to locate one in Nebraska. In recent years, however, the Henslow's sparrow has evidently been seen with increasing frequency in the eastern part of the state, almost always on Conservation Reserve Program (CRP) acreages, which were marginal croplands on highly erodible soils that are now being allowed to return to natural vegetation. Perhaps the day may yet come when I can add this sparrow to my individual list of Nebraskan birds.

The Henslow's sparrow is an inconspicuous grassland bird much like the grasshopper sparrow, with a relatively large bill, striped head, short tail, and a weak, hiccuplike vocalization audible only for short distances. Sutton observed that in contrast to the grasshopper sparrow, the juvenal plumage in the Henslow's is entirely unstreaked below, whereas its adult plumage is distinctly streaked on the breast and flanks.

When Sutton did his fieldwork in southeastern Michigan, the Henslow's sparrow was in a period of rapid local population decline; it was common at the start of his fourteen-year study period and absent by the end. In one area he observed "dozens" of males in an area encompassing about one hundred acres, and in northwestern Pennsylvania he had once estimated that a dozen pairs occupied a grassy habitat of about ten acres. Some authors have described the species as loosely colonial. Sutton observed sixteen nests in 1934, his first year of fieldwork, but apparently none were found thereafter. In 1935 he was brought a brood of four young Henslow's sparrows, which he described as initially being "mostly mouths." They proved especially fond of the smallest grasshoppers that could be found, and consumed them in great quantities. These four sparrows were dubbed "The Henslow's Four" by Sutton, and they reminded him as much of gnomes as of birds. He described them as having a call "like the sigh of some weary elf in the marsh." They were especially troublesome because of their tiny size and fragility, and their elusiveness in avoiding being caught for their regular weighing and measurements.

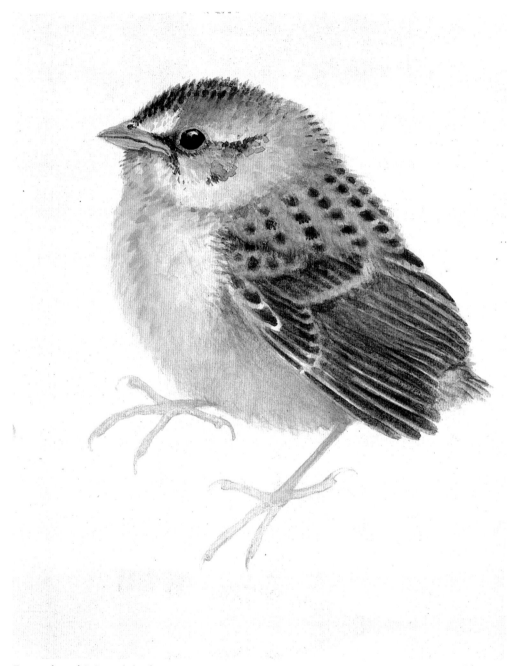

Reproduced 2.0 x original

Plate 29

Nest building is done mostly if not entirely by the female, and she also does all the incubation; meanwhile, the male sings from nearby perches. Both sexes help feed the young, which fledge at the ninth or tenth day after hatching. Although sometimes parasitized by cowbirds, this sparrow's well-hidden nests usually escape the cowbird's detection. Snakes such as racers are probably a more serious threat, both to nesting birds and to their eggs. Two nestings per summer are believed to be typical.

Suggested Reading: Sutton, 1935 (juvenal plumage), 1948 (hand–rearing), 1959 (pt. 4, pp. 127–51, breeding biology); Bent, 1968 (vol. 2, pp. 776–88, general biology); Rising, 1996 (natural history); Robbins, 1971 (breeding biology); Zimmerman, 1988 (habitat selection).

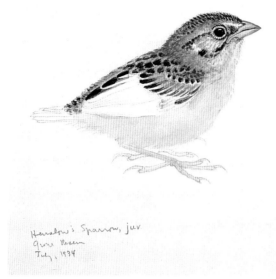

Henslow's Sparrow, juv.
George Reserve
July, 1934

Reproduced .82 x original Plate 30-a

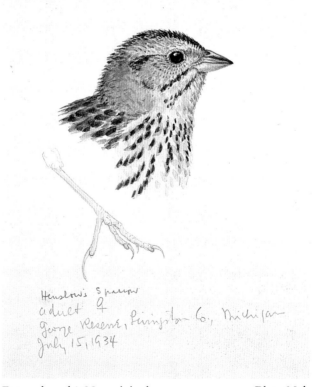

Henslow's Sparrow
adult ♀
George Reserve, Livingston Co., Michigan
July 15, 1934

Reproduced 1.08 x original Plate 30-b

Plate 31

Nelson's Sharp-tailed Sparrow (Ammodramus nelsoni)

I have seen only one sharp-tailed sparrow in my life. As I was walking in a saline marsh area north of Lincoln, Nebraska, where all sorts of interesting birds have turned up over the years, it suddenly appeared in the dense cattail vegetation. I could hardly believe how beautiful the bird was; the golden-toned area around the face and along the sides of the neck was far brighter and richer than I had imagined it would be. Soon the bird disappeared into the marshy grasses, not to be seen again except on my mental list of favorite sightings.

The Nelson's sharp-tailed sparrow, long considered to represent only a geographic race of a much more widely ranging species, is a rather rare and local breeder in freshwater marshes of the continental interior, whereas the coastal form is adapted to breeding in salt marshes of the Atlantic shoreline. Because of their ecological association with sometimes almost impenetrable wetlands and their generally highly elusive behavior, relatively little is known of either species' breeding biology. Like that of the Atlantic sharp-tailed sparrow, the song of the male Nelson's is a prolonged buzzing, but it is perhaps shorter, lower pitched, and more wheezy sounding. Few nests of either species have been found; they are usually built above moist ground and so well sheltered above and all around by a screen of vegetation as to be essentially invisible. At least in the Atlantic coast form, the female alone builds the nest and looks after the eggs and young; promiscuous mating appears to be normal, with the males neither territorial nor involved in parental duties. Four or five eggs constitute the clutch, hatching eleven days after incubation has begun. The juveniles leave their nests at about ten days, by then already a rich buffy yellow on the sides of the head and throat.

Suggested Reading: Bent, 1968 (vol. 2, pp. 795–819, general biology); Byers, Curson and Olsson, 1995 (plumages); Dickerman, 1962 (juvenal plumage); Murray, 1969 (compared with Leconte's sparrow); Rising, 1996 (natural history).

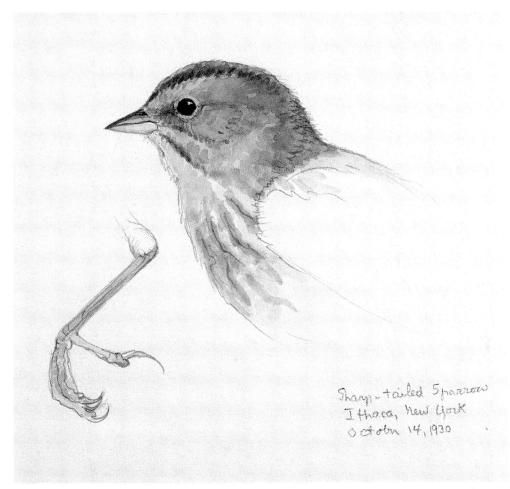

Sharp-tailed Sparrow
Ithaca, New York
October 14, 1930

Reproduced 1.38 x original

Plate 31

Plate 32

Song Sparrow
(Melospiza melodia)

The song sparrow is the all-American sparrow; no matter where one goes, from Alaska to Newfoundland and south into Mexico, some race of song sparrow is bound to be locally present, either as a breeder or at least as a winter resident. The birds seem to have a kind of self-confident can-do attitude and an industrious manner. For me their ebullient song, with its series of three (rarely two or four) distinctive, equally spaced preliminary notes, followed by a wonderful trill, comes close to being the perfect avian song, much like the introductory notes of Beethoven's third symphony. I believe the song sparrow was the first native sparrow I learned to identify as a child while living in a tiny town in eastern North Dakota. When I returned much later as an adult to visit the rural cemetery where my paternal grandparents had been buried, the familiar notes of a song sparrow singing nearby helped ease my sadness as long-neglected memories of childhood came flooding back.

Song sparrows were among the commonest of sparrows nesting at the E. S. George Reserve when Sutton did his fieldwork there. Over a fourteen-year period he found a total of twenty nests, half of which were located above water. The remainder were placed above ground, in red cedar or prostrate juniper vegetation. Probably at least twenty-three chicks fledged successfully from these nests; none was affected by cowbird parasitism. Yet cowbirds are a primary enemy of song sparrows over much of their common range, with half or more of the sparrow nests often affected. The parasitized nests typically reduce a pair's average production of their own young by a single chick, which represents a reduction of about 25–30 percent in breeding success in those areas where at least half of the nests are parasitized. However, song sparrows regularly produce two or even more broods, and the later efforts probably largely escape the brunt of cowbird activities.

Suggested Reading: Sutton, 1935 (juvenal plumage), 1948 (hand–rearing), 1960 (pt. 7, pp. 125–39, breeding biology); Bent, 1968 (vol. 3, pp. 1491–1564, general biology); Nice, 1943 (behavior); Rising, 1996 (natural history).

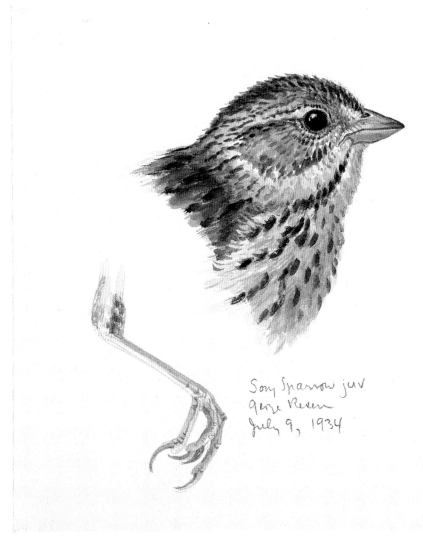

Song Sparrow juv
George Reesum
July 9, 1934

Reproduced 1.53 x original

Plate 32

Appendix

Dates and Locations
of Paintings

Information presented here was noted directly on the paintings by George Miksch Sutton. Names he used are given in parentheses.

Northern Bobwhite (Bob-white)
Plate 1. Arnett, Ellis Co., Oklahoma. June 15, 1936.

Ruffed Grouse
Plate 2. E. S. George Reserve, Livingston Co., Michigan. June 19, 1948.

Lesser Prairie-Chicken (Lesser Prairie Hen)
Plate 3. Arnett, Ellis Co., Oklahoma. June 18, 1936.

Common Moorhen (Florida Gallinule)
Plate 4. Mouilee Marshes, Monroe Co., Michigan. July 1, 1948.

White-rumped Sandpiper
Plate 5. Day-old chick. Jenny Lind Island, Queen Maud Gulf. July 13, 1962.

Yellow-billed Cuckoo (not specifically identified on plate)
Plate 6. Arboretum, Ann Arbor, Michigan. June 24, 1948.

Horned Lark (Prairie Horned Lark)
Plate 7. Ann Arbor, Michigan. June 22, 1948.

Northern Cardinal
Plate 8. No information. This plate was included in Sutton's published account of Crousty, and thus was painted in early August, 1936, at the E. S. George Reserve.
Plate 9. July 27, 1936.
Plate 10. August 3, 1936.

Rose-breasted Grosbeak
Plate 11. Ann Arbor, Michigan. June 16, 1948.
Plate 12. July 17, 1934.

Indigo Bunting
Plate 13. 15 or 16 days old. August 9, 1934.
Plate 14. Left image: Juvenile, July 21, 1934. Right image: Adult, July 25, 1934.

Eastern Towhee (Rufous-sided Towhee)
Plate 15. E. S. George Reserve, Livingston Co., Michigan. July 8, 1948.
Plate 16. E. S. George Reserve, Livingston Co., Michigan. August 3, 1934.
Plate 17. Juvenal. July 18, 1934.

Chipping Sparrow
Plate 18. No information.
Plate 19. Just out of nest. E. S. George Reserve, Livingston Co., Michigan. July 13, 1934.
Plate 20. Left image (a): Male juvenile, July 7, 1934. Right image (b): Adult female, July 25, 1934.

Field Sparrow
Plate 21. No information.

Vesper Sparrow
Plate 22. July 17, 1935.
Plate 23. August 6, 1940.
Plate 24. Main image: E. S. George Reserve, Livingston Co., Michigan. July 16, 1934. Insert image: July 20, 1934.

Savannah Sparrow
Plate 25. No information.
Plate 26. Adult male. E. S. George Reserve, Livingston Co., Michigan. July 15, 1934.

Grasshopper Sparrow
Plate 27. E. S. George Reserve, Livingston, Co., Michigan. July 13, 1935.
Plate 28. "Juv." E. S. George Reserve, Livingston Co., Michigan. July 4, 1934.

Henslow's Sparrow
Plate 29. No information.
Plate 30. Left image: "Juv." E. S. George Reserve, Livingston Co., Michigan. July, 1934. Right image: Adult female, E. S. George Reserve, Livingston, Co., Michigan. July 15, 1934.

Nelson's Sharp-tailed Sparrow (Sharp-tailed Sparrow)
Plate 31. Ithaca, New York. October 14, 1930.

Song Sparrow
Plate 32. E. S. George Reserve, Livingston Co., Michigan. July 9, 1934.

Literature Cited

Arbib, R. et al., 1983. In memoriam: George Miksch Sutton, 1898–1982. *American Birds* 37:135–36.

Beason, R. C., and E. C. Franks, 1974. Breeding behavior of the horned lark. *Auk* 91:65–74.

Bent, A. C. 1940. *Life Histories of North American Cuckoos, Goatsuckers, Hummingbirds, and Their Allies.* U.S. National Museum Bulletin 176. 506 pp.

———. 1942. *Life Histories of North American Flycatchers, Larks, Swallows, and Their Allies.* U.S. National Museum Bulletin 179. 555 pp.

———. 1968. *Life Histories of North American Cardinals, Grosbeaks, Buntings, Towhees, Finches, Sparrows, and Their Allies.* U.S. National Museum Bulletin 237. 3 vols. 1,889 pp.

Best, L. B. 1977a. Territory quality and mating success in the field sparrow. *Condor* 79:303–11.

———. 1977b. Nestling biology of the field sparrow. *Auk* 94:308–19.

———. 1978. Field sparrow reproductive success and nesting ecology. *Auk* 95:9–22.

Best, L. B., and N. L. Rodenhouse. 1984. Territory preference of vesper sparrows in cropland. *Wilson Bulletin* 96:72–82.

Byers, C., J. Curson, and U. Olsson. 1955. *Sparrows and Buntings: A Guide to the Sparrows and Buntings of North America and the World.* Boston: Houghton Mifflin.

Conner, R. N., M. E. Anderson, and J. D. Dickson. 1986. Relationships among territory size, habitat, song and nesting success of northern cardinals. *Auk* 103:23–31.

Dickerman, R. W. 1962. Identification of the juvenal plumage of the sharp-tailed sparrow. *Bird-Banding* 33:202–4.

———. 1968. A hybrid grasshopper sparrow x Savannah sparrow. *Auk* 85:312–15.

Dixon, C. L. 1978. Breeding biology of the Savannah sparrow on Kent Island. *Auk* 95:135–246.

Emlen, S. T., J. D. Rising, and W. L. Thompson. 1975. A behavioral and morphological study of sympatry in the indigo and lazuli buntings of the Great Plains. *Wilson Bulletin* 87:145–79.

Fredrickson, L. H. 1971. Common gallinule breeding biology and development. *Auk* 88:914–19.

Gullion, G. W. 1984. *Grouse of the North Shore.* Oshkosh, Wis.: Willow Creek Press.

Hamilton, W. J. II, and G. Orians. 1965. Breeding characteristics of yellow–

billed cuckoos in Arizona. *Proceedings of the California Academy of Science,* ser. 4 (32):405–23.

Johnsgard, P. A. 1973. *Grouse and Quails of North America.* Lincoln: University of Nebraska Press.

———. 1981. *Plovers, Sandpipers and Snipes of the World.* Lincoln: University of Nebraska Press.

———. 1983. *Grouse of the World.* Lincoln: University of Nebraska Press.

———. 1988. *Quails, Partridges and Francolins of the World.* Oxford: Oxford University Press.

———. A bibliography of George Miksch Sutton. *Nebraska Bird Review.* (In press.)

———. *The Avian Brood Parasites: Deception at the Nest.* New York: Oxford University Press. (In press.)

Kroodsma, R. L. 1970. North Dakota species pairs. 1. Hybridization in buntings, grosbeaks and orioles. 2. Species recognition behavior of territorial male rose-breasted and black-headed grosbeaks *(Pheucticus).* Ph. D. dissertation, North Dakota State University, Fargo.

Maher, W. J. 1986. Nestling diets of prairie passerines at Matador, Saskatchewan. *Ibis* 121:437-52.

Murray, B. G. Jr. 1969. A comparative study of the LeConte's and sharp-tailed sparrows. *Auk* 86:199-231.

Nelson, D. A., and J. Croner. 1991. Song categories and their functions in the field sparrow *(Spizella pusilla).* *Auk* 108:42–52.

Nice, M. M. 1943. *Studies in the Life History of the Song Sparrow. 2. The Behavior of the Song Sparrow and Other Passerines.* Transactions of the Linnaean Society of New York 6. 238 pp.

Parmelee, D. F., D. W. Greiner, and W. D. Graul. 1968. Summer schedule and breeding biology of the white-rumped sandpiper in the central Canadian arctic. *Wilson Bulletin* 80:5–29.

Pasquier, R., and J. Farrand Jr. 1991. *Masterpieces of Bird Art: 700 Years of Ornithological Illustration.* New York: Abbeville Press.

Payne, R. B. 1992. Indigo bunting. In *The Birds of North America,* A. Poole, ed. Philadelphia: Academy of Natural Sciences. 24 pp.

Potter, E. 1980. Notes on nesting yellow-billed cuckoos. *Journal of Field Ornithology* 51:17–29.

Preble, N. A. 1957. Nesting habits of the yellow-billed cuckoo. *American Midland Naturalist* 57:474–82.

Reynolds, J. D., and R. W. Knapton. 1984. Nest-site selection and breeding biology of the chipping sparrow. *Wilson Bulletin* 96:488–93.

Rising, J. D. 1996. *A Guide to the Identification and Natural History of the Sparrows of the United States and Canada.* New York: Academic Press.

Ritchison, G. 1988. Song repertories and the singing behavior of male northern cardinals. *Wilson Bulletin* 100:583–603.

Robbins, J. D. 1971. A study of Henslow's sparrow in Michigan. *Wilson Bulletin* 83:139–48.

Sanderson, G. C. (ed.). 1977. *Management of Migratory Shore and Upland Game Birds in North America.* Washington, D.C.: U.S. Dept. of Interior and International Association of Fish and Wildlife Agencies. Reprint 1980, Lincoln: University of Nebraska Press.

Sibley, C. G., and L. L. Short Jr. 1959. Hybridization in the buntings of the Great Plains. *Auk* 76:443–63.

Sibley, C. G., and D. A. West. 1959. Hybridization in the rufous-sided

towhees of the Great Plains. *Auk* 76:326–38.

Smith, R. L. 1959. The songs of the grasshopper sparrow. *Wilson Bulletin* 71:141–52.

Stokes, A. W. 1967. Behavior of the bobwhite, *Colinus virginianus. Auk* 84:1–33.

Sutton, G. M. 1913. A pet roadrunner. *Bird-Lore* 15:324–36.

———. 1915. Suggested methods of bird-study: Pet road-runners. *Bird-Lore* 17:57–61.

———. 1922. Notes on the road-runner at Fort Worth, Texas. *Wilson Bulletin* 34:3–20.

———. 1928a. *An Introduction to the Birds of Pennsylvania.* Harrisburg: J. Horace McFarland Co. 169 pp.

———. 1928b. An exhibit of bird paintings. *Bird-Lore* 30:104.

———. 1932. *The exploration of Southampton Island, Hudson Bay.* Part 2: Zoology, sect. 2: *The birds of Southampton Island.* Memoirs of the Carnegie Museum 12. 275 pp.

———. 1935. The juvenal plumage and postjuvenal molt in several species of Michigan sparrows. Bulletin of the Cranbrook Institute of Science 3. 36 pp.

———. 1936. The postjuvenal molt of the grasshopper sparrow. University of Michigan Museum of Zoology Occasional Paper 336. 7 pp.

———. 1937. The juvenal plumage and postjuvenal molt of the chipping sparrow. University of Michigan Museum of Zoology Occasional Paper 355. 5 pp.

———. 1941a. Crousty: The story of a redbird. *Audubon* 43:161–68, 270–78.

———. 1941b. The juvenal plumage and postjuvenal molt of the vesper sparrow. University of Michigan Museum of Zoology Occasional

Paper 445. 10 pp.

———. 1943. Notes on the behavior of certain young fringillines. University of Michigan Museum of Zoology Occasional Paper 474. 14 pp.

———. 1949. Baby birds as models. *Audubon* 50:104–8.

———. 1948. Tribulations of a sparrow rancher. *Audubon* 50:286–95.

———. 1959. The nesting fringillids of the Edwin S. George Reserve, southeastern Michigan. Pts. 1–4. *Jack–pine Warbler* 37:2–11, 37–50, 77–101, 127–51.

———. 1960. The nesting fringillids of the Edwin S. George Reserve, southeastern Michigan. Pts. 5–7. *Jack–pine Warbler* 38:3–15, 46–65, 125–39.

———. 1963. Interbreeding in the wild of the bob-white (*Colinus virginianus*) and scaled quail (*Callipepla squamata*) in Stonewall County, northwestern Texas. *Southwestern Naturalist* 8:108–11.

———. 1968. The natal plumage of the lesser prairie chicken. *Auk* 85:679.

———. 1979. *To a Young Bird Artist: Letters from Louis Agassiz Fuertes to George Miksch Sutton.* Norman: University of Oklahoma Press. 147 pp.

———. 1980. *Bird Student: An Autobiography.* Austin: University of Texas Press. 216 pp.

———. 1986. *Birds Worth Watching.* Norman: University of Oklahoma Press. 207 pp.

Verbeck, N. A. M. 1967. Breeding biology and ecology of the horned lark in alpine tundra. *Wilson Bulletin* 79:208–18.

Walkinshaw, L. H. 1933. Nesting of the field sparrow and survival of the young. *Jack–pine Warbler* 10:107–14, 149–57.

Welsh, D. A. 1975. Savannah sparrow

breeding and territoriality on a
Nova Scotia dune beach. *Auk*
92:235–51.

West, D. A. 1962. Hybridization in
grosbeaks (*Pheucticus*) of the Great
Plains. *Auk* 79:399–424.

Westneat, D. F. 1988. Male parental care
and extrapair copulations in the
indigo bunting. *Auk* 105:149–60.

Wheelright, N. T., and J. D. Rising. 1993.
Savannah sparrow. In *The Birds of
North America*, A. Poole, ed.
Philadelphia: Academy of Natural
Sciences. 28 pp.

Wood, N. A. 1974. The breeding behavior
and biology of the moorhen.
British Birds 67:104–15, 137–58.

Wray, T. II, K. A. Strait, and R. C.
Whitmore. 1982. Reproductive
success of grassland sparrows on a
reclaimed surface mine in West
Virginia. *Auk* 99:157–63.

Wray, T. II, and R. C. Whitmore. 1979.
Effects of vegetation on nesting
success of vesper sparrows. *Auk*
96:802–5.

Zimmerman, J. L. 1988. Breeding season
habitat selection by the Henslow's
sparrow (*Ammodramus henslowi*) in
Kansas. *Wilson Bulletin* 100:17–24.

Photo Credits

The Field Museum's negative numbers for the photographs of paintings by George Miksch Sutton included in this volume are as follows:

Plate 1: Z94129c	Plate 18: Z94126c
Plate 2: Z94140c	Plate 19: Z94130c
Plate 3: Z94154c	Plate 20a: Z94142c
Plate 4: Z94136c	Plate 20b: Z94139c
Plate 5: Z94155c	Plate 21: Z94150c
Plate 6: Z94149c	Plate 22: Z94152c
Plate 7: Z94132c	Plate 23: Z94147c
Plate 8: Z94137c	Plate 24: Z94134c
Plate 9: Z94138c	Plate 25: Z94143c
Plate 10: Z94135c	Plate 26: Z94151c
Plate 11: Z94133c	Plate 27: Z94144c
Plate 12: Z94122c	Plate 28: Z94131c
Plate 13: Z94145c	Plate 29: Z94146c
Plate 14: Z94123c	Plate 30a: Z94127c
Plate 15: Z94125c	Plate 30b: Z94153c
Plate 16: Z94128c	Plate 31: Z94156c
Plate 17: Z94141c	Plate 32: Z94148c